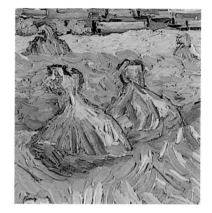

Van Gogh:
Fields

Dorothee Hansen

Lawrence W. Nichols

Judy Sund

Toledo Museum of Art

Published on the occasion of the exhibition VAN GOGH: *Fields,* February 23–May 18, 2003, organized by the Kunsthalle Bremen in partnership with the Toledo Museum of Art.

Major funding by

The exhibition is supported by an indemnity from the Federal Council on the Arts and the Humanities. Additional support provided by the Ohio Arts Council.

This book was made possible in part by The Andrew W. Mellon Foundation.

With the permission of the Kunsthalle Bremen, this book includes reprints, with some adaptations, of the essays "Vincent van Gogh: Biographical Details" and "Van Gogh's Fields: An Interview with Roland Dorn" and the texts of catalogue entry numbers 9–10, 13–14, 16–17, and 24–27 from the Kunsthalle Bremen's exhibition catalogue VAN GOGH: *Fields; The Field with Poppies and the Artists' Dispute,* copublished with Hatje Cantz Publishers, Ostfildern-Ruit, Germany; distributed in the United States by D.A.P., Distributed Art Publishers, inc. ISBN 3-7757-1131-5 (English edition); ISBN 3-7757-1130-9 (German edition).

ISBN: 0-935172-21-1

Toledo Museum of Art
2445 Monroe Street
P. O. Box 1013
Toledo, Ohio 43697-1013

Telephone 419-255-8000
Telefax 419-255-5638

Internet www.toledomuseum.org

Editor: Sandra E. Knudsen

Translator: Steven Lindberg

Designer: Rochelle Slosser Smith

Composition: Garamond and Bauer Bodoni

Printing: Superior Printing Company, Warren, Ohio

Cover and details throughout this book: *Wheat Fields with Reaper, Auvers* (cat. no. 26)

Contents

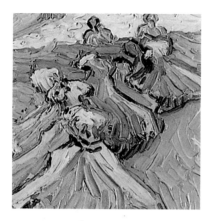

Lenders

Stichting Collectie P. en N. de Boer, Amsterdam

Van Gogh Museum Amsterdam (Vincent van Gogh Foundation)

Fondation Beyeler, Riehen/Basel

Museum of Fine Arts, Boston

Kunsthalle Bremen

The Art Institute of Chicago

The Cleveland Museum of Art

Honolulu Academy of Arts

Indianapolis Museum of Art

National Gallery, London

Tate, London

Solomon R. Guggenheim Museum, New York

The Metropolitan Museum of Art, New York

Carnegie Museum of Art, Pittsburgh

The Saint Louis Art Museum

National Gallery of Art, Washington, D.C.

The Phillips Collection, Washington, D.C.

Kunsthaus Zürich

and Private Collectors

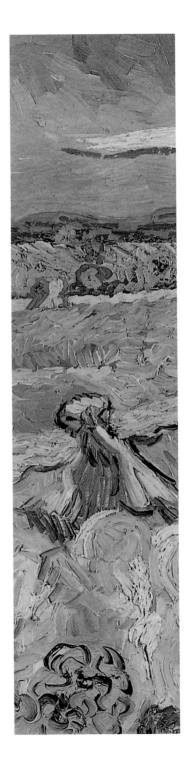

Foreword

The compelling power of Vincent van Gogh's art has played a vital role at the Toledo Museum of Art since 1935, when the Museum purchased both of its paintings by this master: *Houses at Auvers* (cat. no. 18) and *Wheat Fields with Reaper, Auvers* (cat. no. 26). Always highlights in our galleries, on two occasions these paintings were set in context by major Van Gogh exhibitions. In 1953–54, the centenary of Van Gogh's birth, the Museum, in collaboration with the art museums in St. Louis and Philadelphia, hosted a splendid loan show of paintings and drawings from the Vincent van Gogh Foundation, Amsterdam, and the Kröller-Müller Museum, Otterlo. In 1967–68 Toledo exhibited an extraordinary retrospective (presented also in Dallas, Philadelphia, and Ottawa) of Van Gogh's drawings and watercolors, again lent by the Vincent van Gogh Foundation, Amsterdam. It is fitting in 2003, the 150th anniversary of the artist's birth, that the Toledo Museum of Art can again offer its visitors an exceptional experience of the genius that was Van Gogh.

In Toledo, the idea for this exhibition was born five years ago, when the Museum's curator of European painting and sculpture before 1900, Lawrence W. Nichols, proposed an exhibition to focus on Van Gogh's imagery of the field, taking as its point of departure our own *Wheat Fields with Reaper, Auvers.* It later came to our attention that the Kunsthalle Bremen was preparing an exhibition around its important painting *Field with Poppies* (cat. no. 13), in which landscape was to be the subject. Discussions with Wulf Herzogenrath and Dorothee Hansen, director and curator of paintings, respectively, at the Kunsthalle Bremen, resulted in an enjoyable and successful partnership. The Toledo Museum of Art wishes to express its profound gratitude to our colleagues at the Kunsthalle Bremen, as well as to Georg Abegg, president of the Kunstverein, Bremen, for selecting our institution to share in VAN GOGH: *Fields,* which was on view in Bremen from October 19, 2002, through January 26, 2003.

Toledo's exhibition offers a consideration of the scope and character of Van Gogh's representations of the field throughout his short but intense career. Although the subject of landscape has been taken up within other, more expansive contexts, it has not until now been an exclusive focus for consideration. Van Gogh found tranquility and stimulation in the landscape about him, and in his images he sought to represent eternal truths of humanity and nature. Selections have been brought together from each phase of the artist's ten years of work—his initial activity in The Netherlands in the first half of the 1880s; his two years in Paris; and, thereafter, his stays in Arles, Saint-Rémy, and Auvers-sur-Oise from February 1888 until his death in July 1890. This somewhat different approach from the Kunsthalle Bremen's has necessitated a separate publication, but at its scholarly core the exhibition remains unchanged. This is eminently apparent in the catalogue's interview with Van Gogh scholar Roland Dorn, who also provided valuable advice throughout the project.

It is my particular privilege to thank the many lenders to our exhibition, public and private, listed on page four. The Vincent van Gogh Foundation, now in the form of the Van Gogh Museum, Amsterdam, has, fifty years after its first loans to our Museum, again been most generous, and we warmly acknowledge this critical support.

The Toledo showing of this exhibition is made possible through major funding by KeyBank. We are immensely indebted to its sponsorship. Additional support has been provided by the Ohio Arts Council, by an indemnity granted by the Federal Council on the Arts and the Humanities, and by the members of our Museum.

In conclusion, I want particularly to acknowledge the persevering efforts of our curator, Lawrence W. Nichols, for his exceptional attention to the myriad aspects of exhibition preparation that has brought to Toledo such a memorable experience for our visitors.

Roger M. Berkowitz
Director

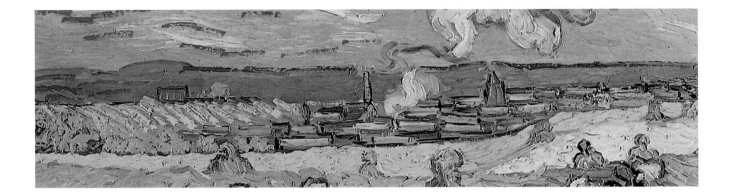

Acknowledgments

A curator's dream is working with a director willing to place his trust in an idea and then follow that up with his energy and time to make it come to fruition. Roger M. Berkowitz is such a director, and without his dedicated leadership and unfailing willingness to support this initiative, VAN GOGH: *Fields* would not have been achieved at the Toledo Museum of Art. I warmly acknowledge his indispensable contribution.

To the director of the Kunsthalle Bremen, Wulf Herzogenrath, and to its curator of paintings, Dorothee Hansen, I owe my deepest thanks. On each step of the way they have gone the extra mile to make our partnership a happy and productive one. Jutta Putschew has also been of valuable assistance.

Idea, directorial support, and collegial partnership would go for naught were it not for the generosity of the lenders. To each institution, foundation, and private collector that has parted with works of art enabling the Toledo Museum of Art to present VAN GOGH: *Fields*, I express my deepest gratitude: Stichting Collectie P. en N. de Boer, Amsterdam, Hilde de Boer; Van Gogh Museum Amsterdam, John Leighton, Sjaar van Heughten, and Louis van Tilborgh; Fondation Beyeler, Riehen/Basel, Ernst Beyeler; Museum of Fine Arts, Boston, Malcolm Rogers and George T. M. Shackelford; The Art Institute of Chicago, James N. Wood, Douglas W. Druick, and Larry J. Feinberg; The Cleveland Museum of Art, Katharine Lee Reid and Carter Foster; Honolulu Academy of Arts, George R. Ellis and Jennifer Saville; Indianapolis Museum of Art, Bret Waller, Anthony G. Hirschel, and Ellen Lee; National Gallery, London, Neil MacGregor, David Jaffé, and Christopher Riopelle; Tate, London, Nicholas Serota; Solomon R. Guggenheim Museum, New York, Tom Krens and Lisa Dennison; The Metropolitan Museum of Art, New York, Philippe de Montebello and Gary Tinterow; Phoenix Art Museum, James K. Ballinger; Carnegie Museum of Art, Pittsburgh, Richard Armstrong; The Saint Louis Museum of Art, Brent Benjamin, Cornelia Homburg, and Francesca Consagra; National Gallery of Art, Washington, D.C., Earl A. Powell III and Philip Conisbee; The Phillips Collection, Washington, D.C., Jay Gates; and Kunsthaus Zürich, Christoph Becker and Jean Rosston. For their help with locating pictures I am indebted to Colin B. Bailey, Walter Feilchenfeldt, George Keyes, Charles S. Moffett, and Adrian Sassoon. I also wish to thank Alice M. Whelihan, Indemnity Administrator for the National Endowment for the Arts, and Michael Findlay.

Our catalogue authors Dorothee Hansen, Roland Dorn, and Judy Sund are to be commended for a trenchant and refreshingly incisive assessment of Van Gogh the landscapist. Their scholarship will have an impact on how we regard this all-important domain of his iconography. Sandra E. Knudsen, coordinator of publications at the Toledo Museum of Art, has indefatigably seen the project through to completion with her normal grace and impeccable standards. Rochelle Slosser Smith skillfully coped with catalogue design, and Steven Lindberg kindly provided German to English translation.

At the Toledo Museum of Art Julia Habrecht, manager of exhibitions, coordinated all aspects of the venture. Her reliability and attention to detail astounds. Karen Serota, associate registrar, wonderfully coped with all matters pertaining to our loans and was supported by Patricia Whitesides, registrar. Installation design was in the able hands of Claude Fixler, and the art handlers Russ Curry, Ales Hlousek, Andre Sepetavec, and Steve Walbolt performed their duties at the highest level. For unflinching support and assistance in numerous other ways, I would also like to thank: Todd Ahrens, Jim Beard, Paul Bernard, Carol Bintz, Jeff Boyer, Cindi Butler, Connie Dick, Giancarlo Fiorenza, Kathy Gee and the Visual Resources Staff, Greg Jones, Darlene Lindner and the Visitor Services Staff, Lance Mayer, Julie Mellby, Anne Morris, Tim Motz, Gay Myers, Kim Oberhaus, Susan Palmer and the corps of volunteer docents, Chris Peiffer, Bob Phillips, Mary Plouffe, Nan Plummer, Carolyn Putney, Elizabeth Sudheimer, Tim Szczpanski, Barbara Stahl, Davira Taragin, Holly Taylor, Heidi Yeager, Judy Weinberg, and Silagh White.

It was George T. M. Shackelford with whom I originally talked about preparing a show devoted to our *Wheat Fields with Reaper, Auvers* (cat. no. 26). He remained a staunch advocate and steady counselor throughout, for which I am beholden. Lastly, to Dorothee Hansen for all her professionalism and knowledge, I convey my utmost appreciation.

Lawrence W. Nichols
Curator of European Painting and Sculpture before 1900

Van Gogh:
Biographical Sketch

Dorothee Hansen

1853

Vincent Willem van Gogh, the eldest son of the Protestant clergyman Theodorus van Gogh (1822–1885) and his wife Anna Cornelia Carbentus (1819–1907), is born in Zundert in North Brabant on March 30. He has five brothers and sisters: Anna (1855–1930), Theo (1857–1891), Elisabeth Huberta (1859–1936), Wilhelmina Jacoba (1862–1941), and Cornelis Vincent (1867–1900).

1864 to 1868

In 1864 Vincent van Gogh begins attending a private school run by Jan Provily in Zevenbergen; prior to this he had attended the village school in Zundert. In 1866 he moves to the Rijks Hoogere Burgerschool of Willem II in Tilburg, which he leaves in March 1868 to return to his family in Etten.

1869 to 1872

On July 30 he starts work as an apprentice with the art dealer Goupil & Cie. in The Hague. His uncle Vincent van Gogh (Uncle Cent) had amalgamated his business and this branch of the French company in 1858. Two other brothers of Vincent van Gogh's father are also active in the art business: Hendrik Vincent (Uncle Hein) in Rotterdam and Brussels, and Cornelius Marinus (Uncle Cor) in Amsterdam.

1873 to 1874

Van Gogh is transferred to the London branch of Goupil & Cie. He travels to London via Paris, arriving in mid-May 1873. In October 1874 he is transferred to Paris. He spends Christmas with his parents in Helvoirt.

1875

In January Van Gogh returns to London, before moving to Paris in mid-May. Here he lives in Montmartre and continues to work for Goupil & Cie., which has now been taken over by Boussod & Valadon. He spends Christmas with his parents in Etten.

1876

Van Gogh asks Boussod to discharge him and leaves Paris in early April. After visiting his parents, he travels to Ramsgate in southeast England in mid-April, where—in exchange for food and lodging— he works as an assistant teacher at Mr. Stokes's boarding school, teaching French, German, and mathematics. In June he moves with the school to Isleworth, a village west of London. Here he subsequently takes up a new job, teaching Bible history at a boys' school run by the Reverend T. Slade Jones. In November he gives his first sermon at the Methodist church in Richmond. He celebrates Christmas with his family in Etten. While there, it is decided that he will not return to England.

1877

From January to March Van Gogh works at the Blussé and Van Braam bookstore in Dordrecht. He decides to study theology and in May moves to Amsterdam to make the necessary preparations.

1878

Studying ancient languages and theology is not to Van Gogh's liking, so he abandons these studies in May, initially returning home to his parents in Etten. Then he attends the preparatory evangelists' seminary in Laken, Belgium, in order to be trained as a preacher. In December he moves to Wasmes in Borinage, a coal-mining district in southern Belgium.

1879

In February Van Gogh begins a six-month probation period as an auxiliary preacher in Wasmes. The Protestant Church Council in Belgium does not extend his contract, however, as he is not considered capable of preaching. Van Gogh nevertheless spends a further year living in seclusion in the town of Cuesmes in Borinage.

1880

The decision to become an artist takes shape in August. In October Van Gogh moves to Brussels, where he enrolls in a beginner's course at the Academy.

1881

In April Van Gogh returns to Etten to live once more with his parents. He continues to study art, now teaching himself (see cat. no. 2). From now on, his brother Theo, who has been working at the main branch of Goupil & Cie. in Paris since 1879, assumes his brother's living expenses. The artist Anton Mauve in The Hague, a cousin of Van Gogh's by marriage, gives him lessons; he paints watercolors and his first studies in oil. Toward the end of the year, Van Gogh moves to The Hague.

1882

Van Gogh lives in The Hague with the pregnant prostitute Clasina Maria (Sien) Hoornik and her five-year-old daughter Maria. His family condemns the relationship.

1883

Sien and her daughter pose for numerous drawings. The relationship ends in September. Van Gogh then moves to Drenthe, where he paints landscapes (see cat. no. 3). In December he returns to his parents, who are now living in Nuenen.

1884

In Nuenen Van Gogh paints views of the Brabant landscape, the weaver series, and numerous depictions of country life. In September he paints a cycle of six decorative works for the dining room of Antoon Hermanns, a former goldsmith. He suggests subject from peasant life that also symbolize the seasons of the year: the sower, the plowman, the shepherd, the wheat harvest, the potato seeding, the ox cart in the snow.

1885

Van Gogh's father dies on March 26. He paints numerous studies of peasants (see cat. no. 4) and *The Potato Eaters,* a large, dark figure composition. Theo quarrels with his brother, criticizing Vincent's "gloomy painting" and reproaching him over unpaid bills for painting materials. From now on, Van Gogh no longer sees himself as his brother's protégé but regards his donations of money as fees for his paintings. To escape the narrowness of village life, Van Gogh moves to Antwerp in November.

1886

Van Gogh studies at the Antwerp Art Academy for a while. In early March he travels to Paris to continue his studies at the studio of the artist Fernand-Anne-Piestre Cormon. While in Paris he lives with his brother Theo, who has deliberately rented a larger flat so that Vincent can set up a studio there. After about three months, Vincent abandons his studies with Cormon. He is introduced to the work of Impressionist painters; he visits the eighth Impressionist exhibition and is very taken by the works of Edgar Degas. He sees works by Claude Monet and Auguste Renoir in exhibitions at the Galerie Georges Petit and encounters the painting of Georges Seurat and Paul Signac at the Salon des artistes indépendants.

1887

In Paris Van Gogh makes important contacts with other artists and exchanges paintings with them. He befriends, among others, Louis Anquetin, Émile Bernard, Armand Guillaumin, Lucien Pissarro, and Signac. He also shares these artists' interest in Japanese colored woodcuts, and in March he organizes an exhibition of such woodcuts at the Café du Tambourin. At the third exhibition of the Société des artistes indépendants Van Gogh encounters the work of the Neo-Impressionists, including Camille Pissarro, Seurat, and Signac. In April he starts painting in Asnières, a suburb to the north of Paris, producing views of the banks of the Seine that are pivotal for his later landscape painting (see cat. nos. 5 and 6). His palette becomes brighter and more colorful, his brushstrokes short like hatching, and sometimes the perspective has the effect of strongly "drawing in" the viewer.

Toward the end of the year Van Gogh organizes an exhibition of his own paintings together with works by Anquetin, Bernard, and Henri de Toulouse-Lautrec at the Restaurant du Chalet; the exhibition is visited by a large number of artists. Van Gogh makes the personal acquaintance of Seurat and of Paul Gauguin, who has recently returned from Martinique.

1888

Van Gogh leaves Paris in ill health and exhausted by life in the big city. He arrives in Arles on February 20 and takes a room at the Hôtel-Restaurant Carrel. See cat. nos. 7 and 8. In Arles he continues to be financed by his brother, who normally sends him fifty francs a week, if necessary 100 francs. Vincent immediately confirms receipt of the money by letter. His precarious financial situation is a constant concern:

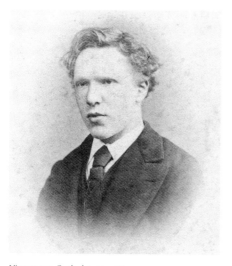

Vincent van Gogh about age 18

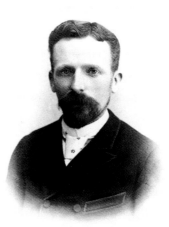

Theo van Gogh

But I tell myself that if I can manage to do fifty studies at 200 francs this year, in a way, I shall not have been very dishonest in having eaten and drunk as though I had a right to it.

Now this is pretty steep, because though I have at the moment about thirty painted studies, I do not value them all at that price. All the same, some of them must be worth it. But the cost of executing them leaves me very, very poor for all that.... (Vincent to Theo van Gogh, about July 8, 1888 [505].)

May 1888

In early May 1888 Van Gogh begins regularly sending his paintings and drawings to his brother in Paris in return for his payments. From April 1888 onward he orders his painting materials from the Parisian dealers Tasset and Père Tanguy through his brother. See cat. no. 9.

In Arles Van Gogh pursues his idea of living together with other artists in an "atelier du sud" (studio of the south). He discusses this ideal of an artists' community with his brother Theo in numerous letters. In early May he rents a four-room house at 2, place Lamartine in Arles for use as a studio. He immediately has the idea of sharing it with another artist:

Well, today I've taken the right wing of this complex, which contains four rooms, or rather two with two cabinets. It is painted yellow outside, whitewashed inside, on the sunny side. I have taken it for 15 francs a month. Now my idea would be to furnish one room, the one on the first floor, so as to be able to sleep there. This [house] will remain the studio and the storehouse for the whole campaign, as long as it lasts in the south, and now I am free of all the innkeepers' tricks: they're ruinous and they make me wretched. (Vincent to Theo van Gogh, early May 1888 [480].)

He calls it the "Yellow House," has it freshly painted, and makes plans for furnishing it. But as he has no money for furniture, he cannot move in as yet. After a quarrel with his landlord about the size of a bill, Van Gogh changes hotels around May 7, taking a room at the Café de la Gare, which is run by Joseph Ginoux and his wife.

Together with Theo, he decides to invite Gauguin to live in Arles. Gauguin is in Pont-Aven at the time and in dire financial straits:

I have been thinking about Gauguin, and look here. If Gauguin wants to come here, there is Gauguin's journey, and there are two beds or two mattresses, which in that case we absolutely must buy. But afterward, as Gauguin is a sailor, we shall probably manage to eat at home.

And the two of us will live on the same money that I now spend by myself. You know that I have always thought it idiotic the way painters live alone, etc. You always lose by being isolated. ... [I]t worries me to spend so much money on myself alone, but the only way to remedy it is for me to find a woman with money, or some fellows who will join me to paint pictures. I don't see the woman, but I do see the fellows. (Vincent to Theo van Gogh, late May 1888 [493].)

June 1888

In March and April Van Gogh paints a series of orchards in bloom. In May he produces landscape paintings of the region around Arles, including *View of Arles with Irises in the Foreground* (cat. no. 9), and toward the end of the month a group of seven drawings of the view from Montmajour, a hill near Arles with a ruin of a medieval abbey. Throughout June, interrupted by a one-week sojourn at the sea in Saintes-Maries-de-la-Mer, he is preoccupied by the theme of the harvest in the La Crau plain, which he had already drawn from Montmajour. Van Gogh paints *Harvest at La Crau* (fig. 1 p. 21), his first "size 30 canvas," i.e., a work in the French standard 73 x 92 cm stretched canvas size, which he was to use frequently for his paintings from then on. Two more size 30 canvases (figs. 2 and 3) and six smaller studies show different aspects of the harvest in La Crau (see figs. p. 22 and cat. nos. 10–12); the study for the painting *The Sower* (fig. 7 p. 24) concludes the harvest series:

But during the harvest my work was not any easier than what the peasants who were actually harvesting were doing. Far from complaining of it, it is just at these times in artistic life, even though it is not the real one, that I feel almost as happy as I could be in the ideal, in that real life. (Vincent to Theo van Gogh, early July 1888 [507].)

The harvest series is dominated by the motif of wheat fields (see cat. nos. 10–12). For Van Gogh these were to become part of an artistic agenda in which everything is related:

The wheat fields have been a reason for working, just like the orchards in bloom. And I only just have time to get ready for the next campaign, that of the vineyards. And between the two I'd like to do some more marines. The orchards meant pink and white; the wheat fields, yellow; the marines, blue. Perhaps now I shall begin to look about a bit for greens. There's the autumn, and that will give the whole scale of the lyre. (Vincent to Theo van Gogh, late June 1888 [504].)

July 1888

In July he returns to Montmajour, where he makes large reed-pen drawings of the view over the La Crau plain. He sends them to his brother,

to refresh your eyes with the wide-open spaces of the Crau. The fascination that these huge plains have for me is very strong, so that I felt no weariness in spite of the really wearisome circumstances, mistral and mosquitoes. If a view makes you forget these little annoyances, it must have something in it. (Vincent to Theo van Gogh, mid-July 1888 [509].)

Van Gogh keeps up a lively correspondence with Gauguin and with Bernard in Pont-Aven. In early July Gauguin writes that he is coming to Arles. Van Gogh sends Bernard a number of drawings done from his paintings of that summer, especially from the harvest series. In early August he sends a further batch of drawings done from paintings to his friend the artist John Peter Russell and to his brother Theo.

August 1888

On August 20 Theo agrees to support Gauguin financially in Arles and to assume his travel expenses. Vincent now needs money to furnish the Yellow House, which he receives in early September. He writes to Bernard about his plan to decorate the house with pictures of sunflowers, which he works on in August. In the weeks and months that follow, Van Gogh expands on this concept for the "décoration" of the house, adding thematic groups such as portraits and *The Poet's Garden*.

September 1888

In mid-September Van Gogh sleeps in the Yellow House for the first time. Theo sends him Japanese woodcuts; lithographs by Eugène Delacroix, Théodore Géricault, and Honoré Daumier; and an issue of the journal *Le Japon artistique*. In early October Van Gogh receives self portraits by Bernard and Gauguin from Pont-Aven. It was he who suggested the exchange and sent Gauguin a self portrait.

October 1888

Gauguin arrives in Arles on October 23 and moves into the Yellow House with Van Gogh. The two artists endlessly discuss their art and exchange ideas. On one of their first joint expeditions through the landscape around Arles, Van Gogh paints a study for a sower and a plowed field. At Gauguin's suggestion, he begins to paint pictures from memory:

Gauguin, in spite of himself and in spite of me, has more or less proved to me that it is time I was varying my work a little. I am beginning to compose from memory, and all my studies will still be useful for that sort of work, recalling to me things I have seen. (Vincent to Theo van Gogh, about November 19–23, 1888 [563].)

November 1888

In late November Van Gogh paints, among other things, two canvases of a sower; these works reflect the influence both of Japanese woodcuts and of Gauguin's painting style. Around that

time Van Gogh also paints his two canvases of chairs, alluding to himself and to his friend Gauguin respectively. The artists' different temperaments are rendered visible in the contrast between the simple straw chair in bright daylight, and the comfortable armchair in the glow of the gas lantern.

December 1888

In the course of December the differences between the two artists become increasingly evident, and Gauguin considers leaving Arles. Matters come to a head on the evening of December 23. After a serious fight with Gauguin—after which the latter spends the night at a hotel—Van Gogh runs to the Yellow House and cuts off a piece of his ear lobe. He then takes it to a local brothel, hands it over to a prostitute named Rachel, and returns to the Yellow House. The following day Van Gogh is found in his bed, showing no signs of life. He is taken to the hospital in Arles, where he is treated by Dr. Félix Rey. Gauguin sends word to Theo in Paris, and he arrives the following day. Without having seen Van Gogh again, Gauguin leaves for Paris with Theo. Vincent remains behind in the hospital. On December 27 he suffers a serious breakdown, which lasts almost a week.

January 1889

Around January 2 Vincent writes to his brother that his condition has improved. On January 7 he leaves the hospital and returns to the Yellow House. He receives visits and help from Joseph Roulin, whose family he had painted in December. Van Gogh paints a self portrait with a bandaged ear. In the same month Gauguin contacts Van Gogh again and writes him two letters; their correspondence continues until Van Gogh's death. Van Gogh does copies of the sunflower paintings he had painted for Gauguin's room the previous August and several versions of *La Berceuse*.

February 1889

On February 7 Van Gogh is admitted to hospital again. A medical report for the police states that he is having hallucinations, hearing voices, and is afraid of being poisoned. As of February 17 Van Gogh is allowed to leave the hospital during the day and work at the Yellow House. Subsequently, thirty neighbours present a petition to the mayor of Arles describing the artist as mentally ill and a danger to women and children, whereupon Van Gogh is again admitted to hospital on February 25 and the Yellow House is sealed by the police.

March 1889

On March 23 Signac visits Van Gogh in hospital. Signac later tells Theo that he thinks Vincent is in the best of health, both psychologically and physically. By late March Van Gogh is allowed to work again. He produces paintings of fruit trees in blossom.

Van Gogh no longer feels in a position to have his own studio and live there on his own. He decides to admit himself to a mental asylum, initially for a period of three months. The Reverend Frédéric Salles, a pastor of the Reformed Church in Arles, who had visited Van Gogh regularly after his breakdown in December, suggests that he go to the Saint-Paul-de-Mausole asylum in Saint-Rémy, a small town about twenty kilometers northeast of Arles. On May 8 he accompanies Van Gogh to Saint-Rémy.

May 1889

On May 9 Dr. Théophile-Zacharie-Auguste Peyron records Van Gogh's arrival in the admissions register, diagnosing epileptic fits. Van Gogh describes his new surroundings to his brother Theo:

I have a little room with greenish-gray paper with two curtains of sea-green with a design of very pale roses, brightened by touches of blood-red. These curtains, probably the relics of some rich and ruined deceased, are very pretty in design. A very worn armchair probably comes from the same source it is upholstered with tapestry splashed over like a Diaz or a Monticelli, with brown, red, pink, white, cream, black, forget-me-not blue, and bottle green. Through the iron-barred window I see a squarefield of wheat in an enclosure, a perspective like Van Goyen, above which I see the morning sun rising in all its glory. Besides this one—as there are more than thirty empty rooms—I have another one to work in. (Vincent to Theo van Gogh, about May 22, 1889 [592].)

For four weeks Van Gogh is not allowed to leave the grounds of the asylum. In the garden he paints flowers and trees, some of them from very close up. He writes to his brother:

When you receive the canvases that I have done in the garden, you will see that I am not too melancholy here. (Vincent to Theo van Gogh, about June 2, 1889 [593].)

At the same time Van Gogh focuses his attention on the view from his bedroom of a walled wheat field and the distant mountains.

June 1889

In early June Van Gogh receives permission to leave the grounds of the asylum. The first landscapes are *Mountainous Landscape behind Saint-Paul Hospital* (fig. 8 p. 27) and *Field with Poppies* (cat. no. 13). He writes to Theo:

My health is all right, considering; I feel happier here with my work than I could be outside. By staying here a good long time, I shall have learned regular habits and in the long run the result will be more order in my life and less susceptibility. That will be so much to the good. Besides, I should not have the courage to begin again outside. (Vincent to Theo van Gogh, about June 9, 1889 [594].)

He paints more landscapes in June, including the first version of *Wheat Field with Reaper:*

… for the days are all the same, I have no ideas, except to think that a field of wheat or a cypress is well worth the trouble of looking at close up, and so on. I have a wheat field, very yellow and very light, perhaps the lightest canvas I have ever done. (Vincent to Theo van Gogh, late June 1889 [596].)

July 1889

Toward the end of June, Vincent does numerous brush and reed-pen drawings from his paintings and sends them to Theo. On July 7 he goes to Arles, accompanied by a warder from the asylum, to visit the Reverend Salles and Dr. Rey, neither of whom is at home. He brings eight paintings back to Saint-Rémy and sends them to Paris.

In early July, Theo, who had married his Dutch fiancée Johanna Bonger in April, tells Vincent that Johanna is expecting a child. Vincent is to be the godfather, and this gives him more courage to face life. On July 16 Theo writes to Vincent telling him that Camille and Lucien Pissarro, Père Tanguy, Erik Theodor Werenskiold, and Octave Maus had seen his paintings. Maus, secretary of the Les XX group in Brussels, asks if Van Gogh would like to take part in the group's next exhibition of avant-garde artists. Theo agrees on Vincent's behalf.

August-September 1889

About one week later, Van Gogh suffers another attack, which this time lasts almost five weeks. It is late August before he is able to return to work, and again his first subject is a field:

Yesterday I began to work a little again—on a thing that I see from my window—a field of yellow stubble that they are plowing, the contrast of the violet-tinted plowed earth with the strips of yellow stubble, background of hills. Work distracts me infinitely better than anything else, and if I could once really throw myself into it with all my energy, possibly that would be the best remedy. (Vincent to Theo van Gogh, late August 1889 [602].)

He assesses his condition with discernment and without illusion:

Now my brain is working in an orderly fashion, and I feel perfectly normal, and if I think over my present condition now with the hope of usually having between the attacks—if unfortunately it is to be feared that they will always return from time to time—of having at times periods of lucidity and activity, if I think over my condition now, then I really tell myself that I must not get too used to the idea of being an invalid. But that I must firmly continue my poor career as a painter. (Vincent to Theo van Gogh, first week in September 1889 [604].)

The exhibition of the Société des artistes indépendants, which includes Van Gogh's *Starry Night over the Rhône* and *The Irises*, opens on September 3. During that same month Van Gogh works intensively in his studio at the asylum (see cat. no. 14). He repeats the painting of his bedroom in Arles and paints two self portraits, and follows these with a second version of *Wheat Field with Reaper.*

While ill, Van Gogh had inadvertently damaged a lithograph after Delacroix, and he now starts to copy it in oils. The work marks the beginning of a whole series of "translations" of graphic models into colored oil paintings, which he produces over the next few months. In addition to Delacroix, Daumier, and Rembrandt, he copies a number of works by Jean-François Millet:

I have now seven copies out of the ten of Millet's "Travaux des Champs." I can assure you that making copies interests me enormously, and it means that I shall not lose sight of the figure, even though I have no models at the moment. (Vincent to Theo van Gogh, about September 19, 1889 [607].)

Over the following weeks Van Gogh considers returning to the north, and the idea crops up regularly in his letters.

October 1889

Toward the end of September or the beginning of October Van Gogh leaves the asylum building for the first time since his attack in July. He paints autumn studies (see cat. no. 15) and pictures of olive groves. Theo informs him that the Dutch artist and critic Joseph Jakob Isaäcson wants to write an article on him for the

journal *De Portefeuille*. Moreover, he tells him that he has spoken to Pissarro about Vincent's desire to return to the north. Pissarro recommended that he go to Auvers-sur-Oise, where there is a doctor who is both an art connoisseur and a friend of the Impressionists—Dr. Paul-Ferdinand Gachet. However, Vincent decides to stay in Saint-Rémy until at least the spring.

From mid-October onward artists such as Isaac Israëls, Jan Pieter Veth, and Théodore van Rysselberghe view Van Gogh's works at Theo's apartment and at Père Tanguy's, where many of his canvases are stored. Van Gogh spends two days in Arles in early November. He visits the Reverend Salles and the Ginoux family, which has his furniture in storage. In Saint-Rémy he paints the field in front of his bedroom window at sunrise. He also does further improvisations after works by Millet.

November 1889

In late November he writes to Maus, confirming his participation in the exhibition of Les XX and naming the six paintings he would like to show. He carries on a lively exchange of letters with Bernard and Gauguin, who tell him about their latest works. Van Gogh rejects their paintings of *Christ on the Mount of Olives,* which are products of their imagination, contrasting them with his own paintings of olive groves, which are based on observation of nature.

December 1889

In December, despite the cold weather, Van Gogh works outdoors, producing studies of pine trees in a storm and other works. The French critic Albert Aurier sees his paintings at Theo's and is very impressed. On December 23 Van Gogh suffers another attack, which lasts almost a week.

January 1890

By early January Van Gogh is working again. Due to the bad weather, he mainly paints in his studio; he does further improvisations after models by Millet, including *The First Steps* (cat. no. 16).

In January Aurier's article *Les Isolés: Vincent van Gogh* appears in the *Mercure de France*. On January 18 the seventh exhibition of Les XX opens in Brussels, with Van Gogh included alongside Paul Cézanne, Pissarro, Renoir, Signac, Toulouse-Lautrec, and others. The artist Anna Boch purchases his painting *The Red Vineyard* at the exhibition for 400 francs.

On January 19 Van Gogh visits Madame Ginoux in Arles. Two days later he suffers another attack, which again lasts about a week.

On January 31 Vincent Willem van Gogh is born to Theo and Johanna, named after his godfather Vincent. In February the latter paints a picture of blossoming almond branches for the newborn child.

February 1890

On February 22 Van Gogh makes another expedition to Arles to present Madame Ginoux with a version of her portrait, called *L'Arlésienne*. While there, he has another breakdown. Dr. Peyron sends two men to bring him back to the asylum in Saint-Rémy. This time his illness lasts many weeks—it is the most serious attack yet. Van Gogh is unable to leave the asylum, but nevertheless fills numerous notebooks with sketches and does a few oil paintings of "souvenirs du nord" (memories of the north), that is, of motifs either from his own studies done in Holland or from memory.

March 1890

The Salon des artistes indépendants opens in Paris in March, showing ten paintings by Van Gogh. Many of his artist friends, including Gauguin and Monet, are very impressed by the works; Pissarro speaks of a real success for Van Gogh. Theo meets Dr. Gachet for the first time and discusses Vincent's condition with him.

April 1890

By late April Vincent is able to reply to his brother's letters:

... not having been able to work for two months, I am very much behind. ... What am I to say about these last two months? Things didn't go well at all. I am sadder and more wretched than I can say, and I do not know at all where I have got to. ... While I was ill I nevertheless did some little canvases from memory, which you will see later, memories of the north... . (Vincent to Theo van Gogh, late April 1890 [629].)

May 1890

In early May he informs Dr. Peyron of his wish to leave the asylum and go to Auvers to be treated by Dr. Gachet. His condition has gradually stabilized, but he is no longer satisfied with his situation in Saint-Rémy:

I think of it as a shipwreck—this journey. Well, we cannot do what we like, nor what we ought to do, either. As soon as I got out into the park,

I got back all my lucidity for work; I have more ideas in my head than I could ever carry out, but without it clouding my mind. The brushstrokes come like clockwork. So relying on that, I dare think that I shall find my balance in the north, once delivered from surroundings and circumstances which I do not understand or wish to understand. (Vincent to Theo van Gogh, early May 1890 [630].)

In the days leading up to his departure Van Gogh works with the greatest intensity. He paints patches of meadow in the park (see cat. no. 17), still lifes of flowers, and the last version of the wheat field (*Field of Spring Wheat at Sunrise*, F 720, fig. 12 p. 27), the motif he could see through the window of his bedroom. This series of fields had preoccupied him during the whole year in Saint-Rémy.

On May 16 Van Gogh is discharged as "cured." The next day he arrives in Paris, where his brother is expecting him. He makes the acquaintance of Johanna and the baby and, with his brother, looks at all the works he had sent him over the past years. They visit Père Tanguy and the Salon du Champ de Mars, where Vincent is highly impressed by a large painting by Puvis de Chavannes. Three days later he leaves the city.

He arrives in Auvers on May 20, finds lodgings at the Ravoux Inn on place de la Mairie, and makes the acquaintance of Dr. Gachet:

Auvers is very beautiful, among other things a lot of old thatched roofs, which are getting rare. ... I have seen Dr. Gachet, who gives me the impression of being rather eccentric, but his experience as a doctor must keep him balanced enough to combat the nervous trouble from which he certainly seems to me to be suffering at least as seriously as I. ... When we spoke of Belgium and the days of the old painters, his grief-hardened face grew smiling again, and I really think that I shall go on being friends with him and that I shall do his portrait. Then he said that I must work boldly on, and not think at all of what went wrong with me. (Vincent to Theo van Gogh, about May 20, 1890 [635].)

Several days later Van Gogh's mood has changed, however, and he intimates that the meeting with his brother in Paris had not been without friction:

... I think that Theo, Jo, and the little one are a little on edge and are worn out—and besides, I myself am also far from having reached any kind of tranquility. ... On the other hand, I very much fear that I too was distressed, and I think it strange that I do not in the least know under what conditions I left—if it is at 150 francs a month paid in three installments, as before. Theo fixed nothing and so to begin with I left in

confusion. Would there be a way of seeing each other again more calmly? I hope so. ... I think we must not count on Dr. Gachet at all. First of all, he is sicker than I am, I think, or shall we just say as much, so that's that. (Vincent to Theo and Johanna van Gogh, about May 23, 1890 [648].)

June 1890

Dr. Gachet invites Van Gogh to lunch or dinner frequently and shows him his house and his art collection. In late May Vincent does an etched portrait of him that is printed on Gachet's own printing press. Van Gogh plans further etchings, but they are never executed. In early June he paints the doctor's portrait and does two studies of his garden; later he does a painting of Gachet's daughter Marguerite. Van Gogh's mood improves as a result of the friendly contact with the art-loving doctor, whom he recognizes as a kindred spirit. Gachet considers Van Gogh to be completely healthy and assumes that no further attacks are to be expected. See cat. nos. 18 and 19.

On June 8, Theo, Johanna, and the baby accept an invitation from Dr. Gachet to visit Auvers. Vincent plans to rent an apartment in Auvers in order to save money and to be better able to store his paintings.

In mid-June Van Gogh returns to the motif of fields. He paints *Landscape with Carriage and Train in the Background* (F 760) and an alfalfa field with poppies. See cat. nos. 20–23. Van Gogh mentions three paintings in a new 50 x 100 cm format, among them *Wheat Fields near Auvers* (fig. 13 p. 32). Over the next few weeks he completes a series of twelve paintings depicting life in the country (see figs. 13–15 p. 32).

July 1890

At the end of June Theo writes Vincent a worrying letter. The baby is very ill, Johanna exhausted, and he himself crippled by money worries, so much so that he is considering giving notice at Boussod & Valadon's and becoming a self-employed art dealer. On July 6 Vincent visits his brother and his wife in Paris. The atmosphere is tense. Aurier and Toulouse-Lautrec are there to speak to Vincent, and Guillaumin is also expected. This is all too much for Vincent and, agitated, he returns to Auvers the same day:

... I am as much in toil and trouble as you are. There—once back here I set to work again—though the brush almost slipped from my fingers, but knowing exactly what I wanted, I have painted three more big canvases

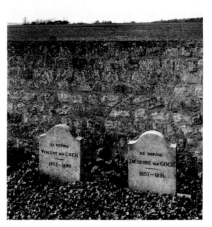

Gravestones of Vincent and Theo van Gogh at the cemetery in Auvers

since. They are vast fields of wheat under troubled skies, and I did not need to go out of my way to try to express sadness and extreme loneliness. ... I almost think that these canvases will tell you what I cannot say in words, the health and restorative forces that I see in the country. (Vincent to Theo van Gogh, about July 10, 1890 [649].)

After his return from Paris, Van Gogh paints the famous *Wheat Field with Crows* (fig. 15 p. 32) and *Daubigny's Garden,* both in the new 50 x 100 cm format. The motif of the fields continues to preoccupy him during the last weeks of his life (see cat. nos. 24–27):

I myself am quite absorbed in the immense plain with wheat fields against the hills, boundless as a sea, delicate yellow, delicate soft green, the delicate violet of a dug-up and weeded piece of soil, checkered at regular intervals with the green of flowering potato plants, everything under a sky of delicate blue, white, pink, and violet tones. I am in a mood of almost too much calmness, in the mood to paint this. (Vincent van Gogh to his mother, about July 11, 1890 [650].)

In a letter written around July 22, Theo assures his brother that his family's situation has improved. Vincent replies in a last letter, the draft of which he is carrying on him at his death. In it he expresses his great appreciation of his brother's efforts, closing with:

Well, my own work, I am risking my life for it and my reason has half foundered because of it (Vincent to Theo van Gogh, draft of a letter, about July 23, 1890 [652].)

On July 27 Van Gogh goes out into the countryside near Auvers and shoots himself in the chest. He drags himself to the Ravoux Inn, where Dr. Gachet and the local practitioner Dr. Mazery are called. Theo rushes to his bedside, arriving on July 28. On July 29, Vincent van Gogh dies as a result of his wound. Friends from Paris, including Émile Bernard, Charles Laval, Lucien Pissarro, Père Tanguy, and Andries Bonger, arrive the following day for the burial at the cemetery in Auvers.

Six months later, on January 25, 1891, Theo van Gogh dies in Utrecht. In 1914 his remains are transferred to Auvers and laid to rest alongside his brother Vincent.

Van Gogh: *Fields*

Roland Dorn, interviewed by
Dorothee Hansen

Van Gogh's Letters as a Source: On the Possibilities and Limits of Interpretation

There is hardly a single other artist about whom we have as much first-hand information as we do about Van Gogh. There are more than 650 letters to his brother Theo and countless letters to his family, to friends, and to other artists. As a result, in many catalogues we can read his day-by-day biography. It seems almost as if there are no more open questions.

Van Gogh's letters are one thing; what has been written about Van Gogh based on them is quite another. Perhaps, for that very reason, we should try from the start to keep things apart where they do not belong together.

Van Gogh's letters offer the best possible way to orient oneself with respect to his biography and his work, even though we are often far from knowing enough, much less everything. Let me give a few examples.

As one leafs through the available documents, one is immediately struck by the gaps. Vincent van Gogh's letters to his brother, Theo, have survived nearly in their entirety; of Theo's replies, however, only a fraction has survived. What was a dialogue between letter writers has largely become a monologue.

The frequency with which letters were exchanged was directly related to the frequency of support payments: Theo sent money and Vincent confirmed its receipt. Changes in the payment arrangements had related effects on the correspondence, depending on whether money could be expected every ten days or once a week.

There were, however, occasional periods in which an exchange of letters would take place from one day to the next or within a few days. This foreshortening sometimes causes problems for the reconstruction of the correct sequence of letters.

When, by contrast, the interval between sequential letters grows longer, we know very little, and we are forced to reconstruct what might have been happening over periods lasting weeks.

Just as the density of the flow of information varies, so does the content of the information. Finally, like all daily communication, Van Gogh's correspondence touches on things that go unspoken, that cannot be articulated. There is virtually nothing intimate, quotidian, banal. Rarely are there more than hints of where he went to eat, when he frequented bordellos or visited booksellers. It is not even certain where he actually bought his paints.

But we do have evidence of orders—from Tasset & l'Hôte, for example, through his brother.

Granted, there are one or two of those. But no one has any idea where the man found his paints in Holland, for example. Today, even reading serious publications, one could gain the impression that we have adequate information on this, nearly everything worth knowing. De facto, it seems, all that has been done is to generalize from the information on details that happens to be available,[1] and this generalization is logically untenable.

A quantum of reliable source criticism and a few fundamental reflections on method and on the epistemological potential of the humanities would enable us to avoid such things. Moreover, we could also bring other questions, perhaps more pressing ones, to the fore. If we can establish the biography, does that really help us with the art? To put it another way, what have we actually achieved for art history?

That is a fascinating question, because again and again we see how passages from the letters are exploited thoroughly for purposes of interpretation.

But that is exactly the question, whether it is justifiable and to what extent. If the correlation is truly one to one, and the passage from the letter demonstrably alludes to a known painting, then no one will have misgivings. But that is not usually the case. Usually the reverse is the case—we have a lot more text than we do direct references. That has the result that more correlations are made between the paintings and the ideas put down in writing than can be documented.

Even ignoring all that, the written exchange does not necessarily address the essential moments of artistic creation.

And that is precisely the issue we are discussing.

Of course, but sometimes the scholarly reception simply goes its own way. In recent decades Van Gogh has been investigated on the basis of the available written sources. These sources, in turn, can be neatly arranged chronologically to produce a very logical division of his oeuvre, in which each change of place rings in a new epoch: Borinage and Brussels (1880–81), Etten (1881), The Hague (1881–82), Drenthe (1882), Nuenen (1882–85), Antwerp (1885–86), Paris (1886–88), Arles (1888–89), Saint-Rémy (1889–90), and finally Auvers (1890). Every catalogue raisonné and every biography drags us through this "tunnel of time periods." When we see things from the perspective of the work, however, it is clear that this minutely detailed partitioning distracts from what is essential.

Seen from the perspective of the paintings, there are many fewer turning points, and they are clearly evident. One begins around the end of 1884, when Van Gogh stumbles upon the complementary contrast while investigating Charles Blanc's color theories. This is a decisive moment, and it is not difficult to read out of the paintings, in the application of pigments he begins to employ. Anyone who knows the primary colors (yellow, red, and blue) and their mixtures (orange, green, and violet) can correctly read the complementary applications of color and will see that something different, something new, is beginning here.

Then, in early 1887, the broken earth tones begin to make room on Van Gogh's palette for the pure, unbroken pigments of Impressionism; and soon thereafter we begin to see that from a certain point on all of the complementary applications begin to waver. By then, of course, we are well past 1885, in late 1888, at least.

The very subtle subdivisions that are normally made between 1885 and 1888 may help antiquarians and iconographers to refine and perfect their systems. From an artistic perspective, however, they are of limited use.

Van Gogh in Arles: The Harvest Series and "Décoration"

What was Van Gogh's initial situation like? What were the artistic possibilities of his intellectual conception of his work in early 1888, when he arrived in Arles?

Van Gogh had gained a wide variety of experience in Paris for two years, namely, experience with contemporary French art. He spent several months in the studio of the salon artist Fernand-Anne-Piestre Cormon. He made contact with the contemporary art scene, with the opposed groups of the "Neos" and the "Cloisonnistes." He met the older generation of the avant-garde, the Impressionists, and learned to appreciate them. But fundamentally he did not know where to begin; there were simply too many impressions. There were those like Monet who worked primarily with color; others were working on formal draftsmanship in the tradition of Ingres, like Degas. But it remained unclear to Van Gogh where he was headed. He began to work, and more or less made it his doctrine to paint whatever came into his sights. That particular problems would become important and become the focus of systematic work, happened only in Arles, after a certain time. And it is characteristic of Van Gogh that the concept he began to develop was more or less determined from outside, and it lay less in the realm of art than in a pre-artistic, extra-artistic realm.

In what realm exactly?

Usually that of ideas communicated in writing and with intellectual content. The most basic concept that arises in this way is that of "décoration." The concept had a very pragmatic origin in the task that Van Gogh set himself in the summer of 1888 of decorating his home and studio in Arles. The decoration was to be practical and straightforward; the "décoration" of the paintings was meant to be the only sign that the rooms were special, that would elevate them above the quotidian.

As Félix Bracquemond demonstrated in his treatise *Du Dessin et de la couleur* (On Design and Color, 1885), this "décoration" was based on a "principe ornemental," an abstract determinant that subordinated all the parts to the whole.

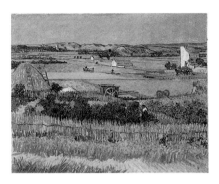

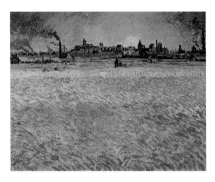

Fig. 1. *Harvest at La Crau with Montmajour in the Background*, June 1888. Van Gogh Museum Amsterdam (Vincent van Gogh Foundation), F 412

Fig. 2. *Haystacks in Provence*, June 1888. Collection Kröller-Müller Museum, Otterlo, F 425

Fig. 3. *Sunset: Wheat Fields near Arles*, June 1888. Kunstmuseum Winterthur, F 465

"La moisson en Provence" (The Harvest Series). Arles 1888: The Paintings

The harvest series was painted between early and late June 1888. During this month Van Gogh also made a journey to Saintes-Maries-de-la-Mer, where he painted two seascapes, among other works. Roland Dorn dates this trip between June 10 and 17, which means that Van Gogh's journey briefly interrupted the harvest series. Ronald Pickvance and Jan Hulsker, on the other hand, believe the visit to Saintes-Maries took place in late May or early June 1888, which would place it before the harvest series.

Van Gogh found the motifs for the harvest series in the plain of La Crau, near the city of Arles. The series includes three large paintings, so-called "toiles de 30" (size 30 canvases). These are canvases with the standard French frame dimensions 73 x 92 cm. This is Van Gogh's largest format, and from here on he will use it repeatedly for especially ambitious subjects. Two of the size 30 canvases—*Harvest at La Crau with Montmajour in the Background* (F 412) and *Haystacks in Provence* (F 425)—are among the earliest paintings in the harvest series; the third size 30 canvas—*Sunset: Wheat Fields near Arles* (F 465)—was, by contrast, painted only after the journey to Saintes-Maries-de-la-Mer.

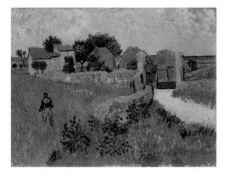

Cat. 10. *Farmhouse in Provence,* June 1888, National Gallery of Art, Washington, D.C., F 565

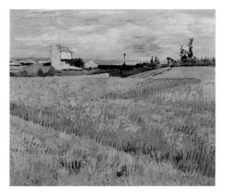

Cat. 11. *Wheat Field,* June 1888, P. and N. de Boer Foundation, Amsterdam, F 564

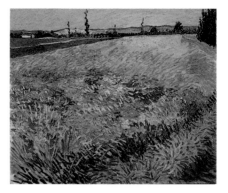

Fig. 4. *Wheat Field with the Alpilles Foothills in the Background,* June 1888, Van Gogh Museum Amsterdam (Vincent van Gogh Foundation), F 411

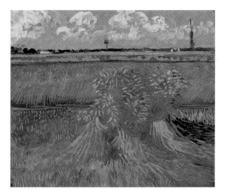

Cat. 12. *Wheat Field: The Sheaves,* June 1888, Honolulu Academy of Arts, F 561

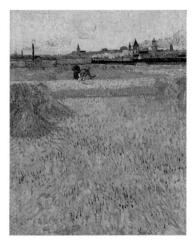

Fig. 5. *Arles: View from the Wheat Fields,* June 1888, Musée Rodin, Paris, F 545

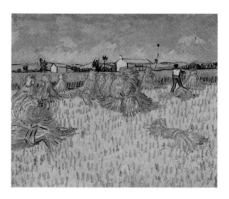

Fig. 6. *Harvest in Provence,* June 1888, Collection The Israel Museum, Jerusalem, F 558

"La moisson en Provence" (The Harvest Series), Arles 1888: The Oil Studies

Also part of the harvest series are six smaller oil studies on various motifs, all measuring about 50 x 60 cm. The order in which they were painted cannot be reconstructed exactly, but *Farmhouse in Provence* (F 565, cat. no. 10) is probably one of the earliest, done before the journey to Sainte-Maries-de-la-Mer, while *Harvest in Provence* (F 558, fig. 6), was probably done only after this interruption.

Van Gogh, who was very familiar with Braquemond's treatise, made the "contraste complémentaire" the overarching principle of his idea for the "décoration." Like the colors, the subjects stood in complementary relationships to one another: near contrasted with far, narrow with wide, day with night, old with new, and so on.

These references, very straightforward at first, which Van Gogh associated with the term "pendants," grew increasingly complex as work on the project progressed. Van Gogh integrated new works by creating complements to already existing works: the modern arterial road is reproduced out of the city (*Vincent's House in Arles,* F 464) and into the city (*The Railway Bridge over Avenue Montmajour, Arles,* F 480), then the railway bridge is juxtaposed with the bridge over the Rhône (*The Trinquetaille Bridge,* F 481).

It is not difficult to understand how this "décoration" functions and to see that Van Gogh had created a superb instrument to explore new subjects. It is equally easy to see, however, that this constant, rampant growth could cause the whole project to explode, for sooner or later only some of the references would remain intelligible. Every new painting simply pushes out an older one.

The end result is fragmentation rather than context. And that is what happened to Van Gogh. In the end, his "décoration" comprised some sixty paintings, most of them "toiles de 30" (that is, size 30 canvases: a standard frame size in France [about 73 x 92 cm]). They could no longer fit anywhere, certainly not in his "little yellow house."

You have been discussing the "décoration" that Van Gogh planned for the Yellow House in Arles. But before he began this "décoration" he had already worked on certain series. He began with flowering fruit trees in the spring of 1888, and that June began the campaign of paintings in the plain of La Crau on the outskirts of Arles: the harvest series. How does the latter relate to the "décoration" and its conception?

In the critical and theoretical statements from around 1890, one can see that for a time "série" and "décoration" were the banners around which the avant-garde groups formed. Impressionists and Neo-Impressionists stuck to the "série"; the circle around Gauguin, from which the Nabis emerged, tended toward "décoration." In the end, we are talking about two sides of the same coin.

At the time he began work on the "décoration" of the Yellow House, Van Gogh was moving away from the term "série." Since terminological precision was otherwise not really his strength, it surely seems advisable to pick up on this distinction. All the more so since it implies other things as well: "décoration" aims for the larger context. "Série" points more to an ever new approach.

When one does not really know where the goal truly lies, the latter approach seems perhaps more natural. In Van Gogh's series of orchards in blossom, however, the point is above all, quite clearly, the artistic mastery of a constantly changing motif—though also with the consideration that these orchard paintings could be combined into decorative arrangements.

As a triptych, for example.

Which also introduces problems—problems that Van Gogh was simply trying to paper over here. In the series of orchards in blossom he considered arranging the paintings in triptychs but avoiding placing lines that dominated a painting, such as a horizon line, in relation to other such lines across the whole.

The same problem arose in the harvest paintings. In those, we can set apart the six paintings in smaller formats that more or less follow the stages of the harvest. Any other intention—to exhibit them as a suite, say—should not be ascribed to them. They were studies that were linked to one another by the context in which they were created, and they merely followed successive stages of the harvest.

The very large-format versions, however, are another matter entirely; they are clearly worked to be counterparts, all three of them. But even the fact that there are three creates a problem of its own. The first two, *Harvest at La Crau with Montmajour in the Background* (F 412, fig. 1 p. 21) and *Haystacks in Provence* (F 425, fig. 2), are clearly connected to one another as the beginning and end of the harvest. So what is a third piece doing in this arrangement at all?

You mean Sunset: Wheat Fields near Arles *(F465, fig. 3)?*

Precisely. There Van Gogh was deviating even in the subject matter, as he treated the theme of the harvest almost as a sideline and moved into the foreground certain intellectual motifs that hardly played a role in the other two paintings, namely, the question of modernity, the conflict between old

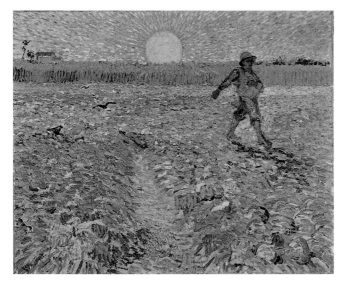

Fig. 7. *The Sower,* June 1888, Collection Kröller-Müller Museum, Otterlo, F 422

The Sower

The motif of *The Sower* (F 422) is loosely connected with the harvest series. At 64 x 80.5 cm, it occupies a place between the size 30 canvases and the smaller oil studies. Van Gogh discussed this painting in depth in his letters. He described it, in contrast to the oil studies, as an "essai de tableau composé" (an attempt at a composition). "Tableaux" were for him paintings that were distinguished by especially ambitious subject matter and aimed for perfection in the traditional sense.

and new, which is suggested by the contrast of traditional farm work and the factory smokestacks, of the historical part of Arles and the modern railway. Thus themes laden with ideas enter into the painting. We are no longer far from "idea painting."

It also fits in with this idea-laden conception that Van Gogh paints the sun in Sunset: Wheat Fields near Arles *in a part of the sky where it would never be seen in reality. Arguments related to form and content are clearly more important here than reproducing nature. Isn't this just a short step from the final piece in the harvest series,* The Sower *(F 422, fig. 7 p. 24).*

As you know, opinion is divided whether *Sunset: Wheat Fields near Arles* depicts the sun setting or the moon rising. I tend to the latter, especially as it also avoids the problem of its placement in the sky.

I find it less difficult to consider the first *Sower* from Arles (F 422) more or less separately, as Van Gogh himself did. But *The Sower* is not the final step, quite the contrary. In Van Gogh's hierarchy, and probably in the chronology as well, it is further advanced.

In the rhythm of farm work, of course, he stands at the beginning. He sows, and the harvest comes at the end

But in Van Gogh's work the sower is never just the simple rustic who cultivates his land; he is the guarantee of continuity. That it will also go on just as it is depicted for all time. All of Van Gogh's sowers groan under this burden of meaning.

Do you mean in terms of subject matter or in the artistic form?

In the first *Sower* from Arles it is not so easy to see where Van Gogh's artistic volition is headed. The description of the painting's color that Van Gogh gives in a letter to Bernard is just as ambiguous as the color disposition that he ultimately realizes and, moreover, different from it. It remains a major complementary contrast, connected with and completed in the Neo-Impressionist style by the addition of the other primary colors. In terms of the application of color, then, it wavers between reproduction and imagination. It is thus completely understandable that Van Gogh speaks merely of an "essai de tableau," an attempt in composition. Probably it was only his belief that the subject of the sower should be central in his oeuvre that kept him from destroying this attempt.

Particularly in the framework of this harvest series, it is obvious that Van Gogh's working methods also changed.

It is a matter of debate whether the harvest series from Arles was painted in one go or in two phases. Neither possibility can be excluded; in the second case, Van Gogh's brief excursion to Saintes-Maries-de-la-Mer would have fallen between the beginning and the end of this harvest series.

Artistically, the latter solution would make a lot of sense, for something seems to have happened in Saintes-Maries-de-la-Mer, as the small group of paintings that Van Gogh brought back from there demonstrates. This is most striking in the two seascapes. *Seascape at Saintes-Maries* (F 417) does not really get a handle on the problem of depicting the moving masses of water, and later revisions turned the impasto into a porridge of paint. By contrast, the waves in *Seascape at Saintes-Maries* (F 415) are separated effortlessly; the brushwork and impasto remain pliant. From precisely this point, it seems to me, begins Van Gogh's progress away from paintings that are simply painted from the gut toward those that with careful consideration solve a set task.

Precisely this difference can also be seen in some of the harvest paintings, which is no surprise, since the masses or planes of waving grain pose a similar problem. If one assumes that the harvest series was produced without interruption, as was and is done occasionally, Van Gogh's development becomes nothing but a progression of leaps.

Which paintings were done before the trip to Saintes-Maries?

Harvest at La Crau with Montmajour in the Background (F 412, fig. 1 p. 21) from the Van Gogh Museum.

And the large-format Haystacks in Provence *(F 425, fig. 2) from the Kröller-Müller Museum in Otterlo?*

Yes, and after that trip to the sea comes the painting now in the Kunstmuseum Winterthur, *Sunset: Wheat Fields near Arles* (F 465, fig. 3).

With its great plain of wheat.

It is one of the most brilliant works from Van Gogh's hand: its execution homogeneous, its impasto flawless, and its condition impeccable! These are the two or three most important works, and then comes the theme of the harvest divided into phases, rendered in six smaller paintings. *Farmhouse in Provence* (F 565, cat. no. 10 and p. 22) from the National Gallery of Art,

Washington, D.C., is one of the first, and consequently it looks almost if it were done with an awl. *Harvest in Provence* (F 558, fig. 6, p. 22) in the Israel Museum, Jerusalem, by contrast, is quite relaxed and probably belongs to the second group, in which the fields have been mown, whereas in the first group the grain is still on the stalk.

Does the new mastery of large surfaces that Van Gogh achieved in the wake of his experiences in Saintes-Maries-de-la-Mer also have something to do with the way he prepared his paintings? In the harvest series we can detect this change in his method.

Probably the two went hand in hand. His preparations were particularly intensive for the large-format paintings—preliminary drawings, color studies using watercolor, and only then execution in oil—until the time of the harvest series. The large *Sunset: Wheat Fields near Arles* (F 465, fig. 3) in Winterthur seems to be the first painting produced without this sort of preparation. According to Van Gogh's own remarks, it was painted in a very short span: "peinte en une seule séance" (painted in a single sitting), I believe he says.

And that is precisely the cliché today for Van Gogh's method as whole: that he painted everything quickly on location in one go.

But of course that is and remains an exception, as he says himself in this passage. We have many indications of the period in which things were made and the length of time it required to get a composition more or less finished. Usually, Van Gogh needed half a day or more even to settle on the composition. Normal elaboration would be followed by a phase of reworking. All that can take quite a while. So when he writes that he painted something in a very short span, in one day, for example, we need to be careful.

A definite concept for the series, one involving the subject matter, clearly did not exist from the beginning in the case of the harvest series. But that did happen with the plans for the Yellow House.

Did Van Gogh ever plan anything seriously? Didn't he rather simply make decisions that had consequences? In the harvest series, in any case, you can see how he created opportunities to produce, suggest, or reveal connections. Later, the intellectual aspect surrounding the series carries a greater weight that what takes place artistically on the canvas. In any case, the connections in the six small-format studies "d'après nature" are decidedly more evident.

It can be said, then, that the harvest series has particular importance. It is a certain point at which something new happens.

It is a turning point, sure.

And a point with a great deal of conceptual thinking, thinking in groups of works with intellectual and formal relationships to one another.

But there was no decision in favor of a concept. That only happens after the harvest series, when Van Gogh decides in favor of "décoration," the vast series for the Yellow House in Arles, which occupied him almost exclusively in the months that followed. In August 1888 it is still a vague notion; in September 1888 it begins to mature; and in October 1888 the "idea of 'décoration'" is defined: complementary contrast as the overarching principle that guides his approach, that sustains the play with straightforward contrasts, and that guarantees the intelligibility of the whole, that ensures "simplicité."

From the Metaphor to the Symbol: En Route to a New Pictorial Language

We would like to jump ahead here, since the "décoration" for the Yellow House has hardly any paintings of fields. We would like to jump ahead to Saint-Rémy. That is a biographical leap that need not be an artistic one, but even so: Does something change in Van Gogh's oeuvre in Saint-Rémy? Is there a fundamentally different approach, or do you see continuity with what had happened in Arles?

Certain changes are visible. This is nowhere more evident than in *Field with Poppies* (F 581, cat. no. 13), now in the Kunsthalle Bremen. There the color relations, the composition, and the draftsmanship play very different roles.

Can you describe more precisely what you mean?

Because heterogeneous trends overlap even in Saint-Rémy, it is rare that all these aspects unite in one painting. What is unmistakable is generally the fusion of color and form in the brushwork, and this becomes a dominant element of the painting. The tensions between the dominant elements of the painting increase (for example, undulating contours, extreme contrasts of light and dark, relief-like gradations of the impasto); the role of details, on the other hand, is weakened. *Grosso modo,* one could say that the level of meaning is shifted somewhat from the subject matter to the process of making.

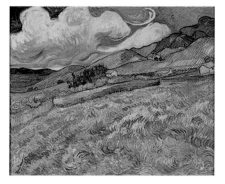

Fig. 8. *Mountainous Landscape behind Saint-Paul Hospital,* June 1889, Ny Carlsberg Glyptotek, Copenhagen, F 611

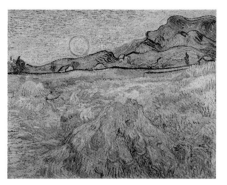

Fig. 9. *Wheat Field with Reaper and Sun, étude,* June-July 1889, Collection Kröller-Müller Museum, Otterlo, F 617

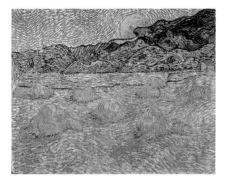

Fig. 10. *Evening Landscape with Rising Moon,* July 1889. Collection Kröller-Müller Museum, Otterlo, F 735

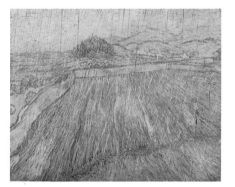

Fig. 11. *Wheat Field in Rain,* November 1889, Philadelphia Museum of Art, F 650

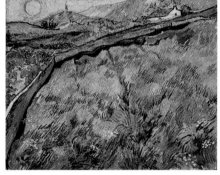

Fig. 12. *Field of Spring Wheat at Sunrise,* May 1890, Collection Kröller-Müller Museum, Otterlo, F 720

The Series of an Enclosed Field, Saint-Rémy 1889–90

Van Gogh worked on the series of paintings of an enclosed field during almost all of his stay at Saint-Rémy, from June 1889 to May 1890. In this series of nine motifs, he painted the view to the east from the window of his bedroom, where a wheat field was bounded by the walls of the hospital grounds and the foothills of the Alpilles rose on the right. The composition *Wheat Field with Reaper and Sun* (F 617, fig. 9) also exists as a repetition (*Wheat Fields with Reaper at Sunrise,* F 618) and as a reduction (*Wheat Field behind Saint-Paul Hospital with a Reaper,* F 619). Another composition, *Enclosed Field with Plowman,* also exists in a second version (*Field with Plowman and Mill,* F 706, here cat. no. 14), where the topography differs significantly from the enclosed field. Both versions are smaller than size 30 canvases, and there is no large-format version of this composition.

Where does that come from? Does Van Gogh write about it in his letters?

Well, that's precisely the most difficult issue. Without a doubt, we are dealing here with a consequence of Van Gogh's collaboration with Gauguin from October to December 1888 in Arles. This is most evident in the early paintings from Saint-Rémy, in which Van Gogh frees himself from his concept from Arles and tries for something new. That sort of thing does not just drop out of the sky, but unfortunately there is no trace of it in the correspondence, just in the paintings and drawings. This means the change cannot be demonstrated in the writings; it has to be *seen*.

Written evidence in which this change is implicit only begins to appear at a time when the decisions had long since been made. The corresponding statements from Van Gogh's side are about, on the one hand, the question of interpretation: What should painting do? Does it reproduce something? Does it interpret a subject? Or are both these things, under circumstances, related? The copies of Millet he made between the fall of 1889 and the winter of 1890 (see cat. no. 16) provided the occasion for this discussion. In most interpretations, this discussion has been limited to the themes the artist addressed (originality and musicality); its explosive effect on the work as a whole has yet to be evaluated.

On the other hand, we are confronted with copies that suddenly appear immediately after Gauguin's departure from Arles. Copies of his own works, sometimes associated with specific goals: one copy is intended for Gauguin, the other perhaps for Bernard, but it is not clear. If we trace back the provenance of these paintings, there is no definite evidence that it actually happened in the way it was perhaps intended. So the question remains: What are these copies for? And if we look at the copies side by side, it is difficult to say that they are minute repetitions; they are really more variations on the same composition. With the *Berceuses* in particular this is more than obvious. The *Sunflowers* can perhaps most likely be said to be copies in the narrow sense.

Probably we need to approach the question from fundamentals and ask what distinguishes the positions of Gauguin and Van Gogh *a priori*. In both cases, it is a question of enlightenment, but in one case the illumination is based on the *creation* of meaning; in the other, on *becoming aware* of meaning. Instead

of the metaphor (from the Greek verb *metapherein,* to carry over) that Van Gogh drags into the painting from outside, a Gauguinian symbol (from the Greek verb *symballein,* to throw or pull together) explores connections.

Give an example of a typical symbol in Van Gogh's paintings.

Typical symbols in Van Gogh—and I would prefer the term *metaphor*—would be the sower and the reaper. In *Wheat Field with Reaper and Sun* (F 617, fig. 9 p. 27) the reaper brings in the harvest; the grain must die in order to give life to others: Van Gogh sought to conceal this ancient metaphor in a melancholic simile.[2] *The Sower* (F 422, fig. 7 p. 24) is the reaper's inevitable counterpart. Without his sowing, there is no continuity of life. Sower and reaper, life and death, had for Van Gogh something of the status of yin and yang in Far Eastern culture.

Does the Christian tradition play a role as well?

Anyone can cram into it whatever he or she wants. Or Van Gogh anticipated that, at least.

And the new, Gauguinian symbol—could you describe that again?

Gauguin searched within his own world of experiments for aspects that are better communicated in images than in words: emotions, fears, and unconscious or subconscious things thus found their way into painting.

And this wasn't communicated by literary means?

Only to the extent that the symbol and the movement called Symbolism offered a platform on which everyone—writers, artists, and scholars—could meet. The literary avant-garde had been discussing the basic tenets of Symbolism since 1886. Gauguin was close to these circles, much closer than Van Gogh, who held on to the dogma of the older avant-garde: the truth, the whole truth, and nothing but the truth. Through Gauguin, Van Gogh was able in the end to gain something from this new trend that would become productive for him. He learned how to see things in relative terms in this way and to express his worldview, "cette vision personelle du monde," about which Guy de Maupassant remarked: "The great artists are those that impose their personal illusion on mankind."[3]

Maupassant's essay "Le roman" was published in *Figaro* on January 7, 1888, and shortly thereafter as the foreword to his

novel *Pierre et Jean*. Van Gogh read the book in March 1888.[4] The novel was concerned with the questions, "What is truly individual?" "What distinguishes individuals?" "What does reality mean exactly?" and "To what extent are the two things connected or are they mutually exclusive?" Maupassant ultimately arrived at the paradox that realism is essentially the most idealistic thing conceivable, since in fact it is not really permitted to be realistic, because in order to come across as realistic it is necessary to exclude the very thing that normally distinguishes reality, namely, all sorts of coincidences. That is not permitted; a flowerpot cannot fall out of a window and hit the protagonist, because no one would consider that realistic.

As was said earlier, Van Gogh respected Maupassant's position and adapted from it the part that seemed useful to him, for example, that the particular must be depicted in order to give expression to normality. But Van Gogh was specifically impressed by the lessons that Flaubert had passed on to his friend and student Maupassant: "In everything, there's something waiting to be discovered, simply because we tend to look at the world only through the eyes of those who have preceded us. The most insignificant thing contains something of the unknown. Let's find it. [...] It is in this way that we become original."[5]

From the View to the Pastiche: *Field with Poppies*

And you see Field with Poppies *(F 581, cat. no. 13) as an example of this?*

It is, first of all, entirely in keeping with the definition of realism: "a field, a whole field, and nothing but a field." That this field can be identified adds little to the matter. And it is only after one has worked with the painting for a long time that the inconsistencies become evident.

If one knows the place where it is supposed to have been painted, then at first one is struck by the differences.

Only the main motif, the poppy field that juts up from the east to the wall surrounding the mental asylum, is approximately correct. The mountains, by contrast, are actually on the opposite side of the asylum, and while in *Field with Poppies* the landscape goes uphill, in reality it goes downhill.

So here we clearly see fundamental differences between Van Gogh's pictorial conception in Arles and in Saint-Rémy?

The Arles paintings, it seems to me, are really views. One looks from a specific standpoint in a specific direction, and as a rule this can be reproduced today. In Saint-Rémy, many problems result if we attempt that sort of thing. Particular aspects can be reproduced, but often a number of standpoints must be found to account for the other details as depicted. We can conclude from this that these paintings are not genuine views (in the sense of a photograph) but are really *composed*. Van Gogh left things out, added things, combined things—whatever he thought necessary.

A good example of this is the quarry that Van Gogh painted twice. On one occasion he gave the motif its proper background; the other time, he did not. In one we see Mont Gaussier in the background (F 635), which is certainly not visible from his standpoint; in the other (F 744) we see in the background the underbrush punctuated by trees that in fact grew there.

Could Field with Poppies *also be explained in this way?*

Field with Poppies suggests a point of view on the path into the fields next to the asylum. We are looking along the walls of the asylum down toward Saint-Rémy. In reality, the land goes slowly and steadily downhill; in the painting, however, it suddenly begins to go uphill again. That means that our view is barricaded from behind; it is captured.

Topographically similar situations can be found elsewhere in Saint-Rémy (such as views along the path through the field toward the mental asylum) but not in *this* field.

Is Van Gogh fitting together set pieces that he has seen?

They are set pieces in the sense that they supplement or transform the main motif and thus establish or displace accents that the main motif does not have in other, similar compositions.

These mountains, the foothills of the Alpilles, that appear in many of the Saint-Rémy depictions of an enclosed field, the one that Van Gogh saw from his bedroom window—can they be seen in this context as well?

Sometimes these mountains look like they do at the site, sometimes they look totally different, namely, as they do from the other side of the asylum. So it seems that Van Gogh played around at will with the things that were familiar to him.

If we keep in mind that he was most likely to have left the asylum through the main entrance, then necessarily he stood facing Mont Gaussier and the foothills of the Alpilles. Seeing the poppy field, by contrast, required a longer expedition, requiring permission to walk around the asylum and the park and perhaps even requiring someone to accompany him. In general, Van Gogh's landscapes from Saint-Rémy somehow have this pastiche character.

Might that also have something to do with the fact that Van Gogh probably had only limited time to spend outside of the asylum, and hence the proportion of studio work was probably relatively large during this phase?

That may have played a big role. We should also add that we now have considerably more drawings, and the question is very much whether they were made *from* the paintings or whether they *preceded* the paintings.

Now it's getting very complicated again. For when we examine the brush drawing of Field with Poppies (F 1494), which probably precedes the painting, it seems more like a pre-existing situation, one that had been seen before. It is not easy to imagine that Van Gogh was already combining various views in this drawing, downward along the wall and another up the mountains. Moreover, in the drawing it is not easy to tell whether it starts to go uphill again in the background.

It remains completely unclear. It could just as well be the case that it goes downhill continually.

Rising mountains of the sort seen in the painting cannot be identified, in any case. Indeed, there are a great number of artistic changes between the drawing and the painting that aim at a clearer symmetry, greater order in the oil painting. Why does Van Gogh introduce these?

Now we are getting into territory that is explosive for art history. For we know precious little about this Van Gogh; we must discuss him more in the future; we have thought long enough about the other one.

Let's take drawing first, as it plays a big role in this period. First, there are drawings from nature, then other drawings from oil studies, usually in a giant format, on full sheets and using many different materials.

Things are changing in his métier. Suddenly there is a structure, or structures, whether with the brush or with the pen, that to some extent makes the motif less clear—something that has almost never occurred previously. The motif was always the most important thing, and Van Gogh's first goal until now was always to say straight out: that is a tree; that is a bridge; that is a cart; that is a bush. Now all of a sudden there are slurs: there is something that becomes a bush; on the other side, perhaps, there might be a bit of wall. In terms of the motif, all of these watercolors from Saint-Rémy are not at all unambiguous.

Even Field with Poppies *itself is not easily legible in terms of spatial disposition, particularly in the foreground with the bushes, which are perhaps more likely trees, and then in the background, where one would expect sky and instead finds rising mountains.*

When Van Gogh transposes sky and mountains, we can assume there are significant artistic reasons for it, such as a desire to terminate the composition above or to intensify the color of the poppy field by adding a relatively neutral color element like the brown of the hills. We still have a number of things to think about here.

Saint-Rémy: The Series of an Enclosed Field

And naturally it would be interesting to know what goal Van Gogh had when he did that. If we take another painting that was made shortly thereafter, Wheat Field with Reaper and Sun *(F 617, fig. 9 p. 27), in which the reaper stands within an enclosed field and does his work, then at first we are reminded of the paintings of the harvest series in Arles. And, indeed, in a letter Van Gogh himself makes a connection between this painting and* The Sower. *And yet are there not differences between this painting and what he painted in the harvest series in Arles?*

There is no linear development at this stage in Van Gogh's work; it was and remains a progression by leaps. Occasionally there are solitary paintings like *Field with Poppies* that anticipate positions that will become important later. On the other hand, there are the usual resonances like *Wheat Field with Reaper and Sun,* for example, which is more or less clearly, even in terms of its subject matter, an echo of *The Reaper* of the previous year.

Have I understood you correctly then? Wheat Field with Reaper and Sun *follows the concept of the metaphor that Van Gogh had earlier in Arles, one that he explains at length in his letters. Whereas, revealingly, he says nothing about* Field with Poppies.

Correct, he says nothing, and it is and remains the dilemma that in Saint-Rémy and also in Auvers essential aspects are not mentioned in the correspondence at all. As a consequence, they are all but non-existent in art-historical discourse, and the relevant paintings are marginalized. Significant examples of this include the two most important paintings of fields (F 720 and F 721), which were simply omitted without any discussion in the reconstruction of his oeuvre in 1990.[6]

You now mention a painting that interests me tremendously. It is probably one of the final paintings of the enclosed field that Van Gogh could see through the window of his bedroom in Saint-Rémy. I am referring to Field of Spring Wheat at Sunrise *(F 720, fig. 12 p. 27) in the Kröller-Müller Museum, Otterlo, in which this field, empty of people, almost pushes out the sky and seems to start to tremble.*

One of the very central works! In Van Gogh's correspondence it is probably mentioned only in passing—referred to simply as *Field*—as it happened to be in Saint-Rémy and had to be sent from there to Auvers. We know no more about this painting; everything else is merely speculation.

The central motif of the painting, the enclosed field, occupied Van Gogh throughout his stay in Saint-Rémy. He painted it ravaged by a storm; with the reaper amid the ripe wheat; a haystack in the moonlight; the bare stubble after the harvest; the fresh green of the sprouting seed; and in the rain.

But this painting is clearly different from anything in the series of the enclosed field. The other paintings do more or less what the variations on *The Sower* and indeed the entire harvest series from Arles did: they trace the cycle of the year. It is done in a decidedly new fashion, with a lot of colorful paint applied, but if it had ended with this series, the result would have been a bit thin.

It took this painting, with its crazy perspective, which is really no perspective at all, with its extreme tension between the application of color and the composition, to achieve something new. It has nothing more to do with what can be perceived; it is pure imagination. Try as we might, it is impossible to see the field like this from any direction. That means that in this painting the motif has condensed into a vision of the field. And it takes its starting point from the wall that surrounds it, from its mortar—and from the disk of the sun.

In that tiny triangle of sky.

The objects depicted are no longer important. The important thing is the form.

There is, on the one hand, this infinite surface that changes from green to yellow, On the other hand, there is the line of the wall that marks inside and out, a wonderfully undulating line that was once a splendid violet; unfortunately, it has probably lost something of its original color. And against this stable balance of colors and lines, a pale yellow sphere stands beaming immovably high in the deep yellow corner. It is quite simply a balance between the uncannily moving and the extremely tensed—the hairs still stand up on my back whenever I see it. Its subject matter has to be read on a much more abstract level; it cannot really be described except in highly abstract forms.

This is now a decisive point. When we see these paintings, we naturally quickly jump to a psychological interpretation. The field, at such a sharp angle, seems to be trying to stretch out. It can also be read the other way around, that an obsession is being pressed out of the field. This step toward Van Gogh's psyche, how do you view it?

Preferably not so directly. It is advisable first of all to distinguish between the painting itself and the patterns of scholarly interpretation that have been applied to the painting. For my part, I'm convinced that only after the deliberately applied interpretive reference points have been exhausted should one reach for psychological speculation.

We briefly addressed such primary reference points earlier. In his copies, for example, Van Gogh was concerned with making the emotional dimensions clear. So we can probably assume that the tendency went in this direction in other works as well. The question is simply: along which lines did it run? And then it always becomes difficult.

Does not that leave us precisely with symbolism, the highly personal and individual forms of expression that Van Gogh acquired during his encounter with Gauguin?

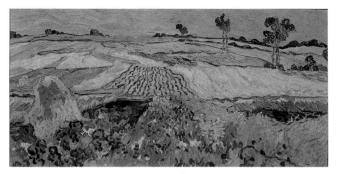

Fig. 13. *Wheat Fields near Auvers,* June 1890, Österreichische Galerie Belvedere, Vienna, F 775

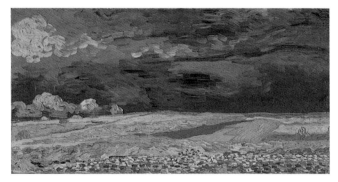

Fig. 14. *Wheat Field under Clouded Sky,* July 1890, Van Gogh Museum Amsterdam, (Vincent van Gogh Foundation), F 778

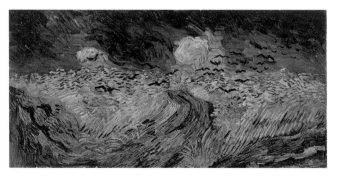

Fig. 15. *Wheat Field with Crows,* July 1890, Van Gogh Museum Amsterdam (Vincent van Gogh Foundation), F 779

The Series on Country Life, Auvers-sur-Oise, 1890

Toward the end of June 1890 Van Gogh used a new canvas size of 50 x 100 cm for the first time. The first paintings in this format were *Wheat Fields near Auvers* (F 775, fig. 13), *Undergrowth with Two Figures* (F 773), and *Landscape with the Château of Auvers at Sunset* (F 770). A few days later he rotated the new format and used it upright for the portrait *Marguerite Gachet at the Piano* (F 772). These four paintings were the start of a cycle that would comprise twelve paintings in 50 x 100 cm format and four paintings in 50 x 50 cm format. The motif of fields played a central role in the series, but it also included *Thatched Cottages by a Hill* (F 793), *Landscape at Auvers in the Rain* (F 811), *Daubigny's Garden* (F 777), and *Tree Roots and Trunks* (F 816).

Four square paintings of 50 x 50 cm depicting children and young women can also be included in this series: *Two Children* (F 783), *Child with Orange* (F 785), *Portrait of Adeline Ravoux* (F 786), and *The Little Arlésienne* (F 518). In combination with the rectangular format canvases, they form a decorative frieze that presents the essential themes of country life.

Yes. But Van Gogh also learned from Gauguin that personal symbolism is not of much use if it cannot communicate. It is necessary from a practical perspective, then, that it be legible on the other side.

Apparently that is not the case here.

Are you sure? Certainly they were intended to be legible. The question is, how directly, and in that regard Van Gogh clearly had different approaches and models. And above all else, there is another question with uncertain implications, namely, how closely he let these, let us call them "deeper levels," come personally, how existentially threatening he found them, and so on. There is, of course, the often-cited passage, in a letter to Bernard, about the "rouge-noir" feeling[7] that addresses such aspects, fear of life or existential dread. That sort of thing is somewhat supported by psychology. But such passages from letters have more significance for psychological literature than for art-historical literature.

It is fair to question, however, whether abysses open up behind every brushstroke. Certainly there are gradations and probably even differences of substantial nature that should perhaps be taken seriously. When Van Gogh speaks of one of the fields in terms of the health that he feels when looking at it, and of another in terms of the threat of the vision or impression that he gives to these fields, it may be that not everyone will follow him, but it may simply be that we do not yet have in hand the right key to his remarks.

The great difficulty for the interpreter is to translate what Van Gogh painted into words and then pass it on.

It is probably just as important to block out all that has already been said. These stories probably make the innocent eye impossible. Who can really take a naive look at *Wheat Field with Crows* (F 779, fig. 15 p. 32)? It is not possible, because so many interpretations have already been made of it.

You once characterized the painting Field of Spring Wheat at Sunrise *(F 720, fig. 12 p. 27) as the final tableau in the series of an enclosed field. Can it really be called a series, and how would you characterize it in comparison to the harvest series from Arles?*

It is certainly possible to speak of a series. It is short, but ultimately it is an annual cycle. Van Gogh kept attempting that again and again. Perhaps it was a mania, perhaps a pressing need as well—what do I know? In any case, there are always extensions or deviations that distinguish these cycles. This means that the harvest series in Arles is composed differently from the one in Saint-Rémy, and that drawing sometimes plays no role at all and elsewhere is very important again.

In the asylum at Saint-Rémy, Van Gogh was first faced with the problem of having to or wanting to get himself together again; a problem of a purely biographical nature. And then the problem of somehow overcoming the difficulties at the asylum so that he would even be allowed to go out the door. I can imagine that that required some effort in itself. The question of what he should paint probably came third. But there he probably always had a couple of ideas—more or less thought out, but just ideas—which were often just repetitions of what he had already attempted.

What was truly new in Saint-Rémy, in my view, is best seen in the drawings, the watercolors, made at the very start. They move away from the description of objects of the sort that was always in Van Gogh's work before: contour and then some kind of filling out. Now, instead, they emphasize structure. Then structure complements the subject matter, provides coherence within this group of drawings, and ultimately flows into important paintings like *Field with Poppies,* in which he juxtaposes or relates color planes and structures. This reaches its peak in *Field of Spring Wheat at Sunrise* in Otterlo, although I do not necessarily want to make a judgment about the quality of one painting or another.

So it really is a step toward abstraction, even if Van Gogh would certainly not have referred used the term.

He would, at least, have understood the term to mean something quite different. For Van Gogh, abstraction was something rather objectionable, meaning something more like simplification, in the sense that his colleagues Bernard and Anquetin simplified contours and colors. But perhaps that is all a misunderstanding; certain things suggest that might be the case. However that may be, Van Gogh never wanted or attempted that sort of abstraction—this is well documented, so we needn't trouble ourselves about it.

But neither did he mean abstraction in our modern sense: a breaking free from the description of the object. I am thinking primarily of the little field in the National Gallery, London, Meadow in the Garden of Saint-Paul Hospital *(F 672, cat. no. 17), whose effect for us today is almost like an abstraction. Here Van Gogh is seeking a subject that is almost entirely without objects or motifs of the traditional sort that he could reproduce. Instead, it is the structures of various grasses interlocking that become his theme.*

Structures—sometimes strictly similar ones, sometimes layers of lines in opposition, sometimes of changing color, sometimes homogeneous, and so on—are characteristic of Van Gogh's painting from the autumn of 1889 onward. As a rule, the goal of all variants in his brushwork is and remains the description of the object. To that are added at most emotionally laden components that he himself introduces in this context: originality, for example, or especially musicality.

A classic catchword today in the context of abstraction.

Sure, but perhaps he just picked that sort of thing up somewhere. In any case, I have yet to find the source.

But one thing is clear: music speaks directly to the emotions, without literary symbols. And that is comparable to this kind of painting. But now we are going too far in one direction....

Fields in Auvers: The Series on Country Life

… in the end, Van Gogh, shortly after he painted the tableau of the Field of Spring Wheat at Sunrise *(fig. 12 p. 27) we have been discussing, found his way to Auvers. There again he began with a very definite series, in which once again the motif of the field plays a major role.*

But now unambiguously in a style of the kind we have just described: defined by structures that support the series as a whole, and no longer necessarily by corresponding subjects, which have become more secondary motivations of the whole.

So it is characteristic that no more sowers appear (very rarely a small reaper will occur). Usually it is broad plains empty of people that Van Gogh now depicts.

If we look at the many depictions of plains from Auvers, systematically, one after the other, the impression is anything but one of emptiness or monotony. The subject matter of most is grain per se, from a blade of straw to the waving fields of the plains of Auvers, while others distinguish the stages of the course of the year.

More fundamental, however, is the division according to types of painting based on a purely external feature like format. Size 30 canvases or other standard formats continue to be views (or something close to that), but now there are also paintings of unusual formats, 50 x 100 cm or 50 x 50 cm. The former depict fields, haystacks, sheaves of straw, underbrush, roots, and so on, something like the motif turned into pure concept; while the latter usually show small children or older children. Strange, is it not?

Do you have an explanation?

50 x 50 and 50 x 100 cm—that easily produces a frieze; moreover, the suggestion that portraits could be combined with depictions of fields is one Van Gogh made himself.

So it is possible to establish that Van Gogh in Auvers now arrives at a proper, planned cycle with these special square and rectangular format paintings. That cannot be said for the paintings of fields made in Saint-Rémy. There one simply follows another in a series.

Planned or not. In Arles, and Saint-Rémy, too, everything is planned in one way or another. If you leave enough out or overlook it, at some point you will get the impression that something belongs together. But the sum of parts is not necessarily the completeness—the whole—that Van Gogh aimed for. That was more of a continuity of meaning than a group display.

To achieve such a whole, Van Gogh always needed only one part of his paintings. Probably it did not occur to him at all to use everything; probably he always intended to leave all sorts of things out, to omit them.

Perhaps it was more important to him to create bridges between the various formats and types of paintings as necessary. In Auvers, in any case, there is a certain correspondence between square and double-square canvases, on the one hand, and the paintings of standard French sizes, on the other. For that reason, these two series of formats can also be combined without difficulty.

That is to say, you do not view it strictly at all, with the double-square canvases as a frieze, but actually believe that most of the paintings produced at that time could be combined. That is, that Van Gogh's whole oeuvre is always filled with interrelations. One work corresponds with another, as it were?

No other interpretation is possible if we look at the sketches for juxtaposing various subjects of a decorative sort that Van Gogh made in his letters. They are based on precisely this mutual complementarity. His wish to combine *Marguerite Gachet at the Piano* (F 772) with one of the paintings of a field (F 775, fig. 13 p. 32) was certainly not based on their respective compositions. Not even in the subdivision of the composition does *Marguerite Gachet* correspond to anything in this painting of a field. Van Gogh himself merely pointed to the color scheme. We will have to be satisfied with that, for the time being, but there lies the beginning of a solution to the problem.

So you believe then, to return for a moment to the turning points in Van Gogh's oeuvre, that the method of working that he developed in Saint-Rémy continues in Auvers?

Definitely.

And yet what happens between Field with Poppies *(F 581, cat. no. 13), which was painted in the early period in Saint-Rémy, and* Landscape with Carriage and Train in the Background *(F 760), now in the Pushkin Museum, Moscow, painted a year later? Both paintings have comparable perspectives—views over a mosaic of fields, for example—but a year lies between them. Can one see another development or not?*

The *Field with Poppies* in Bremen is an attempt in which it is clear that it is a first attempt: with corrections wet in wet, changes in the original pictorial and color concepts, and so on. From the moment that it became clear to Van Gogh what he should and must be concerned with, such things were avoidable. That happened quite soon after the beginnings represented by the *Field with Poppies,* but it happened in intervals, as attacks of his sickness intervened. But by October or November 1889 at the latest, his hand was so practiced that it truly functioned. He was more or less in confident command of *alla prima* painting that did not need

to be corrected and that realized the qualities of *Field with Poppies* in a free way.

This mastery of artistic means is particularly striking for me in the Moscow painting. There he was not working in layers at all, as he did in Field with Poppies; *there are hardly any corrections, and in places there is heavy impasto directly against prepared canvas. It is clear that it was probably painted more or less in one go. At least, we are not aware of any preparatory drawings for the paintings in Auvers.*

Nor is it likely there were any. The quantity of work that Van Gogh produced in Auvers is enormous. We know of about seventy-two paintings, thirty-three drawings, and one etching that he made in these nine weeks.

So in the end we return to the widespread cliché that Van Gogh always painted very quickly.

There is no getting around that. But it only becomes programmatic at the very end of his career, in connection with the terms *musicality, originality,* and so on. It is true of everything that Van Gogh refers to in this last phase of work, all of which takes place somewhat independently of the subject.

In the earlier works it isn't true, but only where the rhythm of the brush communicates that the field, the wonderful motif or the reality, is being subordinated to the painterly context. Such stories show that Van Gogh is clearly free from the direction in which he began, that even for him there could be no way back to the real literary banalities or literary inspirations.

Nature, of course, the model of nature!

That is something else. It remains the yardstick, but the question of personal implementation—of how I conceive the motif—is the decisive aspect, to a much greater extent than in Saint-Rémy. In Arles the personal was still anchored far too much in the motif; in Auvers it is more or less concentrated in the execution.

Epilogue

That would be a wonderful sentence with which to conclude. But I would like to ask two final questions, by way of a summary. When most people think of the artist Van Gogh, the first thing that occurs to them is the sunflowers; second, the self portraits; but they do not often think of the fields. This motif seems not to be so familiar for Van Gogh. What role does it play in his work?

People do think of the fields; but perhaps they don't perceive the fields, just the crows.

It is extraordinary what Van Gogh developed from the subject matter of fields in various paintings. Completely different views over broad, distant fields, above which stands the deep blue sky, and then direct confrontations with the blades, which take away any possible view. There is a quotation from him in a letter from July 1890 to his brother, Theo, and Theo's wife, Johanna, in which he says about the broad wheat fields: "I did not need to go out of my way to try to express sadness and extreme loneliness." And then one sentence later comes the exact opposite: "I almost think that these canvases will tell you what I cannot say in words, the health and restorative forces that I see in the country."[8] That means the paintings are for him open even in what they express. The fields are for him a very open metaphor for the widest variety of things.

There are subjects that can be called, with good reason, metaphors, because they are intended as such—*Starry Night* (F 612), for example. With the fields it is something else. They are not metaphors. The tracks along which something is being realized there do not lie on the metaphoric plane, but are close to what Goethe called a *symbol*. That means that the term and the idea are of equal value. One *sees* in it what it *is*. One can read it directly; there is no need for detours by way of erudition. That's what Goethe found so nice.

And that is why Van Gogh preferred painting as a means of expression and did not want to communicate these things in words.

He may have been thinking exactly that. Even his painting always strives in this direction. Always away from any symbolism in the foreground that was otherwise so popular during this period. Always toward the important, the genuine.

And yet Van Gogh says nothing about this in his letters, but when it comes to the clear metaphors of the sower or the reaper he writes all sorts of interpretations to his brother.

From the perspective of the literary scholars among art historians, those paintings are always the most important; that which lasts. From the perspective of painting, however, it is other paintings about which he says nothing, but they are at least as important. And there is a lot of work to be done.

Is it possible to draw a line from these works in Auvers to the art of Modernism?

Not necessarily in the sense of the handwriting as the primary intention. For Van Gogh, the "stroke" remains a secondary phenomenon, overlapping and resulting from the object, which gradually rises until it has a certain independent value.

Van Gogh's reception in the twentieth century has usually gone in the other direction, so that *how* something is made is the most important thing.

But precisely that cannot be said of Van Gogh. If one zone in a painting seems almost abstract to us—because we do not immediately recognize what each brushstroke means—that does not by any means indicate that Van Gogh wanted to refer to his painting; rather, he meant the foliage, the grass, or something else concrete.

Moreover, if it is a question of pure painting during this period, there are surely better examples.

For example?

How about Manet or Cézanne? Or Gauguin?

Notes

1 See coll. cat. Amsterdam 1999, pp. 20–21.

2 Vincent to Theo van Gogh, about September 2–5, 1889, in *The Complete Letters of Vincent van Gogh.* 3 vols. (Greenwich, Conn.: New York Graphic Society, n.d. [1958]) vol. 3, pp. 201–207 [letter 604], quotation on p. 202: "But there's nothing sad in this death."

3 Guy de Maupassant, "The Novel," in idem, *Pierre and Jean,* trans. Julie Mead (Oxford: Oxford Univ. Press, 2001) p. 9.

4 Vincent to Theo van Gogh, about March 18, 1888 [470], quotation on p. 534: "I am in the middle of reading *Pierre et Jean* by Guy de Maupassant. It's good. Have you read the preface, where he explains the artist's liberty to exaggerate, to create in his novel a world more beautiful, more simple, more consoling than ours... ?"

5 Guy de Maupassant, "The Novel" (above note 3) pp. 12–13.

6 See exh. cat. Amsterdam 1990.

7 Vincent to Émile Bernard, about November 28, 1889 [B 21], quotation on p. 524: "sensation of anguish, called 'noir-rouge.'"

8 Vincent to Theo van Gogh, about July 10, 1890 [649], quotation on p. 295.

Roland Dorn was born in 1952 in Arzberg, Upper Franconia, Germany, studied art history in Regensburg and Mainz, and has done research in Paris and Amsterdam. In 1986 he received his Ph.D. with a dissertation on Van Gogh's "décoration" for the Yellow House in Arles, which was awarded the C.I.N.O.A. prize for writing on art in 1987.

In 1986–89 Dr. Dorn was an assistant curator at the Kunsthalle Mannheim, where he worked on the exhibitions *Carl Schuch, Die Haager Schule,* and *Émile Bernard.* In 1990 he was guest curator for the exhibition *Vincent van Gogh und die Moderne* at the Museum Folkwang Essen and the Van Gogh Museum Amsterdam; in 1995 he curated the exhibition *Van Gogh und die Haager Schule* at the Kunstforum, Vienna.

In 1995–99 Dr. Dorn worked on the Paul Cassirer Archive, as scholar-in-residence at Walter Feilchenfeldt in Zürich. He is a member of the scholarly committee advising on the critical edition of Van Gogh's correspondence that is being published by the Constantijn Huygens Instituut, The Hague, and the Van Gogh Museum, Amsterdam.

Roland Dorn lives in Zürich and works as a freelance art historian.

Catalogue

Authors:

D. H.	Dorothee Hansen
L. W. N.	Lawrence W. Nichols
J. S.	Judy Sund

Catalogue Organization

The catalogue follows the same sequence as the sections of the exhibition.

Introduction (cat. no. 1)
Section 1: The Early Years (cat. nos. 2–4)
Section 2: Paris (cat. nos. 5 and 6)
Section 3: Arles (cat. nos. 7–12)
Section 4: Saint-Rémy (vat. nos. 13–17)
Section 5: Auvers-sur-Oise (cat. nos. 18–27)

Titles

The titles of works by Van Gogh vary from one book to another, and the situation is made more complicated by the use of multiple languages (Dutch, English, French), so in this catalogue the titles have been revised and edited. They generally follow the English titles according to *Vincent Van Gogh: The Complete Works* (CD-ROM; Toronto 2002), preceded by French titles as given by Van Gogh in his letters. Titles of works not mentioned in the letters are listed in English only.

Wherever Van Gogh provided remarks about specific works, such as "drawing from nature" or "drawing based on a study in oil," these have been added to the title. For some titles not indicated by Van Gogh himself, the standard English title is listed along with (where appropriate) the name of the series to which it belongs, such as "La moisson en Provence" (Harvest in Provence). Although this system is subject to the limitations posed by a number of exceptional cases, it does provide a means of offering important supplementary information in the titles of works.

Van Gogh's Letters

The literature on Van Gogh is full of precise date attributions derived from Van Gogh's correspondence. Yet one tends to forget that most of these dates are based upon reconstructed evidence and are still under discussion among scholars. The reason for this is that Van Gogh dated his letters only on rare occasions. In this catalogue, we rely on the letter dates provided by Roland Dorn and Ronald Pickvance but precede most date entries with "about," in order to emphasize that they are approximations rather than proven datings.

The letter numbers printed in this catalogue are those in *The Complete Letters of Vincent van Gogh,* 3 vols. (Greenwich, Conn. New York Graphic Society 1958); the numbers of the letters are given in square brackets. For discussion of the sequence and dating of the letters, see:

Ronald Pickvance, in *Van Gogh in Arles,* exhibition catalogue, The Metropolitan Museum of Art, New York 1984, pp. 262–263.
Ronald Pickvance, in *Van Gogh in Saint-Rémy and Auvers,* exhibition catalogue, The Metropolitan Museum of Art, New York, 1986, pp. 291–292.
Roland Dorn, *Décoration: Vincent van Goghs Werkreihe für das Gelbe Haus in Arles,* Hildesheim 1990, pp. 477–530.
Roland Dorn, "'Refiler à Saintes-Maries?' Pickvance and Hulsker revisited," *The Van Gogh Museum Journal,* vol. 3 (1997–98) p. 25.

Abbreviations used to identify individual works:

F Jacob-Baart de la Faille, *The Works of Vincent van Gogh. His Paintings and Drawings,* rev. ed. A. M. Hammacher et al. (Amsterdam 1970).

JH Jan Hulsker, *The New Complete Van Gogh. Paintings, Drawings, Sketches. Revised and enlarged edition of the Catalogue Raisonné of the Works of Vincent van Gogh* (Amsterdam/Philadelphia 1996).

1 Self Portrait

Spring 1887
Oil on artist's board, mounted on cradled panel,
41 x 32.5 cm (16 $\frac{1}{8}$ x 13 $\frac{1}{4}$ in.)
Chicago, The Art Institute of Chicago
Joseph Winterbotham Collection, 1954.326
F 345 JH 1249

Raised amid the fields and farmers of provincial Holland, Vincent van Gogh would always consider himself a country boy at heart. He was, however, no country bumpkin. As the son of a university-educated minister of the Dutch Reformed Church, Vincent grew up in a bookish household that stood apart from the prevailing rusticity of his home town, Zundert, and was off to boarding school at age eleven. His youthful interest in pictures was predictable: Three of his paternal uncles bought and sold art for a living, and Vincent was groomed for that family business. He spent six years as an art dealer in The Hague, London, and Paris, "gradually becoming a cosmopolite," as he noted in one of the hundreds of letters he wrote to his younger brother, Theo, also a dealer.

Throughout his brief life, Van Gogh felt an essential divide within himself: country boy coexisted with cosmopolite, workingman with aesthete. In almost three dozen self portraits made between 1886 and 1890, the artist surveyed the opposed personas his being encompassed. In addition to showing himself as a palette-wielding professional before his easel, he made images of himself in a laborer's blue blouse and straw hat, and as an embattled survivor: ear bandaged, head floated on a sea of swirling brushstrokes. Self portraiture's appeal—for Van Gogh, as for other practitioners of the genre—resided not only in its convenience but also in its myriad possibilities for self-exploration and -presentation. "One and the same person," he noted, "may furnish motifs for very different portraits."[1]

This example, made in the first months of 1887, shows Van Gogh as the cosmopolite who emerged some years before and resurfaced from time to time. Attired in jacket and tie, hair neatly brushed back, expression serious and a touch world-weary, this Van Gogh has little of the eccentric artist about him, much less the tortured genius of popular imagination. Donning the mantle of middle-class respectability, he instead enacts the mild-mannered bourgeois his family would have him be.

When he made this self portrait, Van Gogh was in the process of rethinking his work in response to that of the Parisian avant-garde. Curiosity about recent developments in Paris was one of the factors that contributed to Van Gogh's relocation to that city, where he would reside (with up-and-coming dealer Theo) for two years. Though his first glimpses of avant-garde painting caused him "bitter, bitter disappointment,"[2] Vincent was gradually won over. Under the spell of pictures examined at the final group show staged by the Impressionists and at the 1886 Salon des artistes independents, he set about lightening his palette and touch—urged on not only by his brother but also by painter friends including Paul Signac (1863–1935), whom Van Gogh met at an art supplies shop in the winter of 1886–87.

A friend and disciple of Georges Seurat, Signac was a forceful proponent of the style that had been christened Neo-Impressionism after its prominent display at both the last Impressionist show and the Salon des artistes independents of 1886. Pioneered by Seurat, this "new Impressionism" was, like the movement from which it sprang, concerned with capturing the effects of natural light on contemporary subjects, directly observed. But whereas Impressionism looks spontaneous and unrehearsed, Neo-Impressionism has a studied quality that derives, in good measure, from the manner of paint application Seurat advocated. Using tiny dots and dashes of pigment, closely juxtaposed (a technique called "pointillism"), Seurat aimed to break perceived color into its component parts (and thus labeled his practice "divisionism"). By 1886, several other artists had adopted Seurat's approach, but none was more committed than Signac, who actively proselytized on the movement's behalf. Working in Signac's company in the first months of 1887, Van Gogh painted a number of pointillist works in which coloristic opposites (red/green; blue/orange; yellow/violet) are paired to scintillating effect.

Here, Van Gogh uses his own countenance as an arena of experimentation, viewing familiar terrain through a novel lens. He plays up the opposition in his own coloring—exaggerating the green of his eyes, heightening the red tones of complexion and beard—and does a muted variation on this red/green pairing in the jacket. The image is further activated by a backdrop abuzz with the sparkling interactions of blue and orange.

One of Van's Gogh's most purely pointillist works, this self portrait surely was made before Signac left Paris in May 1887. Thereafter, Van Gogh employed a mixed technique, in which small dabs continued to dapple the surfaces of pictures built of larger strokes (see cat. no. 6). Having refined his touch and brightened his palette at Signac's side, Van Gogh left Neo-Impressionist orthodoxy behind, though pointillism remains a trace element of his mature style.

J. S.

[1] Vincent to Wilhelmina van Gogh, June/July 1888 [W 4].
[2] Ibid.

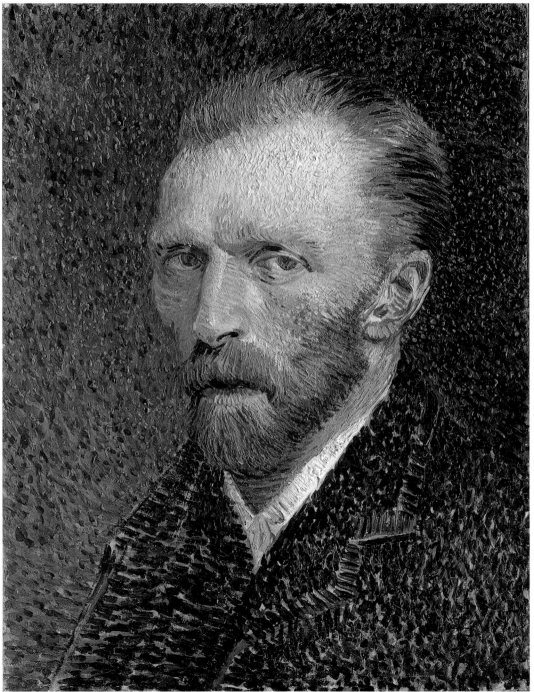

2 Landscape (Fields near Etten)

April–May 1881
Watercolor and graphite on paper, 19 x 28 cm (7 1/2 x 11 3/16 in.)
St. Louis, The Saint Louis Art Museum
Purchase, 6:1954
F 874v JH 3

It is a blustery day in mid-spring. Skies have cleared enough to entice a lone walker into puddled fields. In a composition dominated by verticals—of spindly trees, lanky human figure, distant chimneys, and stands of grass that muster in the foreground and fall out beyond—scattered horizontal dashes denote patches of standing water in typical lowlands terrain. The trees' gauzy veils of new-grown foliage announce seasonal change, but washes of icy-hued pigment suggest a lingering chill in these northern climes.

Believed to be one of Van Gogh's earliest surviving works, this pen drawing with watercolor highlights was made near the small Dutch town of Etten, where the artist's father ministered to the town's Protestant community. In the previous year, the younger Van Gogh—an aspiring preacher himself—had been dismissed from his lay evangelist's post by superiors who found his speaking style wanting. Demoralized, but determined to find his way in the world, he had decided that picture-making (an endeavor he'd pursued as an amateur since his youth) might be his salvation. "In spite of everything," he decided, "I shall rise again: I will take up my pencil, which I have forsaken in my great discouragement, and I will go on with my drawing."[1] Taking cues from how-to-draw manuals, and making copies after works he admired, the would-be artist honed his representational skills through independent study.

After a brief stay in Brussels, he moved to his parents' home, eager to draw the scenes he knew best and the subjects closest to his heart. As he later wrote to Anthon van Rappard, another fledgling Dutch artist he had met in Brussels, "… you and I cannot do better than work after nature in Holland … [where] we feel at home, then we are in our element…. we must never forget that we have our roots in the Dutch soil."[2] Images of the sorts of Brabant landscapes Van Gogh explored in his youth are prevalent in his work from Etten, and may be read as affirmations of the rootedness he sought for himself after years away from home.

"Every day that it does not rain," he wrote to Theo from the parsonage, "I go out in the fields, generally to the heath."[3] This scene's single figure might be seen as a stand-in for the artist himself, their interconnectedness suggested by the figure's solitariness (Van Gogh, a loner by nature, was certainly a fish out of water as a practicing artist in the Dutch provinces) and his pastime (rather than working the land, he surveys it).

Having purchased a treatise on watercolor in his first weeks at Etten, Van Gogh made tentative attempts to colorize his pen drawings. At this point, however, his work's liveliness derived almost exclusively from calligraphic effects, and the surface animation of this landscape manifests a career-long penchant for them. From the start, Van Gogh favored the broad strokes he could achieve with reed pen, such as those seen in the foreground here. Given its early date, this drawing's similarities to those Van Gogh produced in Provence years later are notable. Like the reed-pen drawings he made in and around Arles in spring 1888, this one is built of a wide range of marks that enliven a broad, sparsely occupied vista.

The rich vocabulary of strokes Van Gogh developed while working exclusively as a draftsman (from 1880 to 1882) stood him in good stead when he turned to painting. He eventually learned to translate striations, cross-hatches, and curly-cue pen strokes into the highly textural brushwork that marks his signature style in oil (e.g., cat. nos. 10, 13, 15, 18, and 26).

J. S.

[1] Vincent to Theo van Gogh, September 24, 1880 [136].
[2] Vincent van Gogh to Anthon Ridder van Rappard, October 15, 1881 [R 2].
[3] Vincent to Theo van Gogh, May 1881 [145].

3 Heath with Wheelbarrow

Autumn 1883
Watercolor and gouache over traces of graphite (?) on paper,
24.3 x 34.9 cm (9 $^{13}/_{16}$ x 14 $^{1}/_{16}$ in.)
Cleveland, The Cleveland Museum of Art
Bequest of Leonard C. Hanna, Jr., 1958.30
F 1100 JH 400

In September 1883, tired of his enervating existence in The Hague (where he had lived for some twenty months and was plagued by problems in his personal relationships as well as financial woes), Van Gogh longed anew for work in the open countryside. Having heard Drenthe's quaint charms extolled by urban colleagues, the artist set out to explore that out-of-way province in the northeastern Netherlands. "In order to grow," he wrote Theo, "one must be rooted in the earth," and "the soil of Drenthe," he believed, "was the perfect place to dig oneself in.[1] The Van Gogh brothers' native Brabant had seen a fair amount of modernization since their shared boyhood. Drenthe, by contrast, was virtually untouched by the Industrial Revolution, and its vast heath—the domain of peat farmers, bargemen, and the occasional painter in search of real rusticity—appeased Vincent's nostalgia for the bygone landscapes of his youth.

He made a base for himself at Hoogeveen, in western Drenthe. Though "classed as a town on the map," Hoogeveen struck him as little more than a village: "just a long row of houses along the harbor,"[2] unrelieved by a single tower. Its clutch of low buildings soon gave way to flat meadowland, where "the planes vanishing into infinity" put Van Gogh in mind of a vast sea or desert: "monotonous" and "inhospitable," yet serenely beautiful.[3] "What tranquility, what expanse, what calmness in this nature," he exclaimed.[4]

This watercolor is an apt visual counterpart to the verbal images of Drenthe that Van Gogh regularly sent his brother. At twilight, he noted, the "vast, sun-scorched earth stands out darkly against the delicate lilac hues of the evening sky, and the very last little dark-blue line at the horizon separates the earth from the sky."[5] Through the rising haze, he noted, "one can just see at the horizon a bluish-gray line of trees with a few roofs."[6]

Short on supplies (he had "only a very few colors with me"[7]), Van Gogh painted Drenthe in a minimalist manner that seems well suited to the simple, unvarying scenery his letters describe. This image, a case in point, features a reductive palette of steely greens and blues warmed ever so slightly by touches of gold and pink. The composition is as uncomplicated as the color scheme. The ground plane consists of horizontal bands that narrow toward the horizon and are differentiated mainly by texture: the loose, loopy cadences of the foreground and angular choppiness at mid-ground give way to unruffled parallel strokes beyond.

The dearth of materials he complained of from Drenthe may account for Van Gogh's several forays into watercolor—a medium he usually avoided, in the conviction that its inherent fluidity was ill-suited to his own ingrained tendency to bear down hard on his motifs.[8] A draftsman by training and inclination, Van Gogh rarely allowed himself to go with the flow of watercolor to the extent seen here. The amorphous patches of hue that dance across the foreground are much less typical of the artist's watercolors than the carefully drawn contours of the wheelbarrow, which hold the paint's looseness in check and counter the freeform effects that dominate.

In addition to showcasing Van Gogh's proclivity for wielding a paintbrush like a pen, the painting's wheelbarrow implies human presence in an unoccupied landscape. Captivated by the postures of laborers he observed in Drenthe, the artist was disappointed by workers' unwillingness to be painted (even if well paid to do so). Here, a peat farmer's simple conveyance would seem to substitute for its owner. Left idle for the moment, it betokens both work and rest as it jauntily punctuates the fields' flatness.

J. S.

[1] Vincent to Theo van Gogh, November 1883 [336].
[2] Vincent to Theo van Gogh, September 1883 [323, 329].
[3] Vincent to Theo van Gogh, September 1883 [325].
[4] Vincent to Theo van Gogh, September/October 1883 [330].
[5] Vincent to Theo van Gogh, September 1883 [325].
[6] Ibid.
[7] Vincent to Theo van Gogh, September 1883 [323].
[8] See, for example, Vincent to Theo van Gogh, spring 1883 [297]. In this letter (written just months before his sojourn in Drenthe), Van Gogh asks, "Can one blame me, if, following this emotion, I don't express myself in watercolor, but in a drawing only with black or brown?"

45

4 Peasant Man and Woman Planting Potatoes

About April 11, 1885
Oil on canvas, 33 x 41 cm (13 x 16 1/8 in.)
Zürich, Kunsthaus Zürich
Inv. Nr. 1860
F129a JH 727

In a muddy-looking landscape that bespeaks early spring, a woman and man—probably man and wife—perform a rustic task in tandem. He turns the earth with a spade, making it ready for the seed potatoes she lets fall. Even as their personal partnership is alluded to by the reciprocity of their labors, the couple's connectedness (even subservience) to the land is suggested by the fact that neither figure breaks the horizon line that separates the flat plain and its surround of thatched cottages from a leaden, cloud-streaked sky.

Van Gogh made this painting in Brabant, the agrarian district in which he had been raised. He had returned there once again in 1883, this time to Nuenen, where his father was minister to the Dutch Reformed congregation. While living at the parsonage there, Van Gogh painted several local field workers. His best-known painting from Nuenen, *The Potato Eaters* (F 82), was completed some two weeks after *Peasant Man and Woman Planting Potatoes*, and might be considered its thematic sequel. As Van Gogh noted, the family pictured in *The Potato Eaters* were manual laborers who "dug the earth with those very hands they put into the dish."[1]

Though nineteenth-century epicures considered potatoes unfit for human consumption, country folk who could scarcely afford bread (let alone meat), cultivated and dined on them with increasing regularity—leading Scots philosopher Thomas Carlyle to characterize society's have-nots as "root eaters."[2] Visual images of potato farming—if still vastly outnumbered by pictures of wheat being sown and reaped—were not unknown to art lovers by the time Van Gogh first tackled the subject in 1881.[3]

His earliest depictions of potato planting are single-figure drawings of men digging alone. Van Gogh's decision to add women to such scenes was perhaps prompted by seeing a couple at work, but just as likely was inspired by Jean-François Millet's *Potato Planting* (1861–62; Museum of Fine Arts, Boston), in which a man and woman work in concert. Though he probably had not seen Millet's painting, Van Gogh "knew" it from its description in Alfred Sensier's biography of Millet (1881), a book he read and re-read in the early 1880s. Sensier

writes there that Millet's *Potato Planting*— "one of his most beautiful works" —shows husband and wife "on a wide plain, at the edge of which a village is lost in the luminous atmosphere; the man opens the ground, and the woman drops in the seed potato."[5]

In September 1884, Van Gogh included an image of a couple planting together in a suite of paintings meant to represent the seasons of the year by way of their characteristic labors. Commissioned by Antoon Hermanns, an amateur painter who took lessons with Van Gogh, the cycle was inspired by a long tradition of Labors of the Months imagery and designed with Millet's oeuvre in mind (most particularly Millet's picture series *The Labors of the Fields* and *Four Seasons*). Though Van Gogh originally envisioned a potato *harvest* as part of Hermanns's suite (and, to that end, made a drawing of a man and woman digging side by side [F 1141]), he soon revised the image list, having settled potato *planting* as apt evocation of springtime. He then painted two variations on that theme. One shows a woman dropping seed potatoes into the furrow made by the plowing man she trails (F 172); the other is a multi-figure composition in which five solitary figures flank a central pair who face each other as they bend to their task (F 41).

Neither of these earlier formulations is as resolved or as intimate in feeling as the *Peasant Man and Woman Planting Potatoes* Van Gogh made the following spring—the one exhibited here—wherein he isolated the man and woman who work *en face*. In doing so, he virtually reprised Millet's composition (though his knowledge of doing so was vague at best). Van Gogh's satisfaction with the *Peasant Man and Woman Planting Potatoes* he made in April 1885 is indicated by the fact that he sent drawings of the finished picture both to his brother in Paris and to Hermanns.[6] That he considered it his definitive take on the subject is suggested by the fact that Van Gogh ceased to paint potato planters after making it.

J. S.

[1] Vincent to Theo van Gogh, April 30, 1885 [404].
[2] Thomas Carlyle, *Past and Present* (London 1843) p. 195; cited by Griselda Pollock, "Van Gogh and the Poor Slaves: Images of Rural Labour as Modern Art," *Art History* 11 (1988) pp. 408–432, 426–427. Louis van Tilborgh notes that French moralist La Bruyère already had equated root-eating with poverty in *Les caractères de Théophraste* (Paris 1688) vol. 11, p. 128; see L. van Tilborgh, *The Potato Eaters by Vincent van Gogh* (Zwolle 1993). On nineteenth-century potato eating, see also Alexandra R. Murphy, *Jean-François Millet*, exh. cat., Museum of Fine Arts, Boston, 1984, p. 143; and Louis van Tilborgh, in exh. cat. Amsterdam 1988/89, pp. 34–35.
[3] See, for instance, the sketches the artist included in letters to Theo van Gogh in September and October 1881 [150, 152].
[4] Alfred Sensier, *Jean-François Millet: Peasant and Painter* (trans. Helena de Kay) (Boston 1896) p. 149.
[5] Louis van Tilborgh, "Les quatre saisons," in exh. cat. Paris 1998/99, pp. 68–79, p. 75.
[6] Vincent to Theo van Gogh, about April 11, 1885 [399], and postcard to Hermanns, April 1885 [399a].

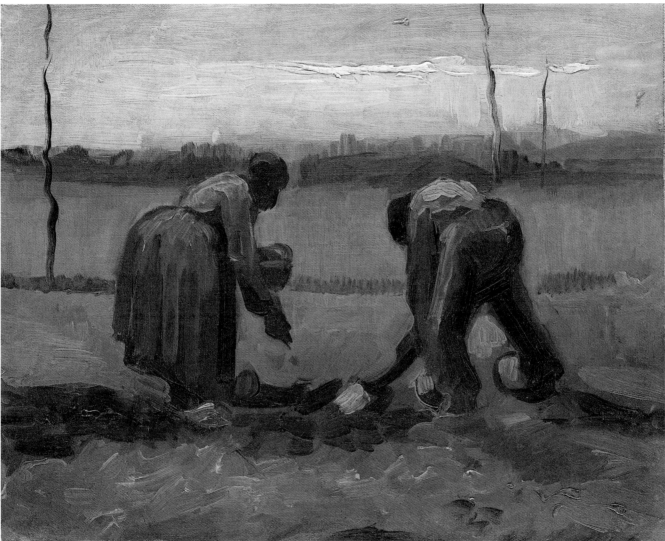

47

5 Edge of a Wheat Field with Poppies

Summer 1887
Oil on canvas on pasteboard, 40 x 32.4 cm (15 ³/₄ x 12 ³/₄ in.)
Private Collection
F310A JH 1273

Van Gogh's two-year sojourn in Paris from 1886 to 1888 produced remarkably few urban vistas. Living with Theo on the southern slope of the Butte Montmartre—the chalk hill that stood at the city's north edge—the artist tended to paint life in his own neighborhood, a still-rustic enclave where cafés and apartment houses coexisted with windmills and market gardens.[1] When he ventured off the hill to paint, Van Gogh was little inclined to set up his easel in the heart of the city. He preferred to trek northward, making his way to the crest of the Butte, then, veering slightly westward, down to the fortified walls that marked the city's northern edge, and through the Porte de Clichy, a gateway to the city's northwestern suburbs. There, where the Seine looped up behind the city, meadowland adjoined the towns and factories that shadowed its banks.

The course Van Gogh followed was a popular one with Parisian workers who, on Sunday promenades, set their sights on a bit of open space. Contemporary novelists had chronicled the route,[2] and in the 1880s it was well trodden by painters intrigued by admixtures of old and new in the region just beyond the city walls. In 1887, Van Gogh painted there often with both Paul Signac and Emile Bernard (each of whom had a family home in Asnières).[3]

While some of the paintings Van Gogh made in the northern suburbs chronicle encroaching industrialization (see cat. no. 6), the majority focus on open-air pleasures to be had in the environs of Paris: boating on the Seine, strolling its banks, dining *al fresco* on sunny restaurant terraces, lolling in the grass on warm spring days. Bernard fondly recalled Van Gogh's "sketches of the Seine filled with boats, islands with blue swings, fashionable restaurants with multicolored sunshades …deserted little corners of a park or country house for sale. Those little sketches … breathed a spring-like poetry. I reveled in their charm, all the more because I then lived in those surroundings…."[4]

The corner of nature Van Gogh recorded in this small landscape encapsulates the airy charm Bernard recalled (though the vibrancy of its hues is more summery than spring-like). It may, as is widely supposed, be part of a wheat field: a margin at which poppies and rogue grasses interlace with cash crop. The foreground's long yellow grasses, however, lack wheat's characteristic grain-filled heads, and the steep slope on which they grow suggests an embankment rather than a workable field.[5] Since Van Gogh's paintings of the banks of the Seine show similar inclines,[6] the painting may just as well show overgrown shoreline as cultivated land.

The picture is one of Van Gogh's most impressionistic, and the freedom of its paint surface (where long, loose strokes adjoin splotches and slabs of impasto), contributes to the untamed look of the place. Despite his initial dismay at the "slovenliness" of Impressionist pictures—which he found "badly drawn, badly painted, bad in color" in 1886[7]—Van Gogh had come to appreciate their vivacity. The palette employed here resembles the Impressionists' in the purity of its hues, which, if adulterated at all, were lightened with white. This constituted a radical shift for Van Gogh, who, in Holland, mixed black into color to tone it down.

As he himself acknowledged in retrospect, the artist's extended stay in Paris provided him "the opportunity to study the question of colors," and "when I was painting landscape at Asnières last summer [i.e., 1887], I saw more color in it than before."[8] The tints in this example span the spectrum, with neutrals all but banished. The painting's darkest silhouettes are deepest green rather than black, and its drabbest tones—the grays of the tree trunks—are overlaid by unexpected rose-pink highlights. Touches like this would seem to reflect Van Gogh's belief that "what is required in art nowadays is something very much alive, very strong in color,"[9] and his conviction that "the painter of the future will be *a colorist such as has never yet existed.*"[10]

J. S.

[1] As his colleague Émile Bernard (1868–1941) later remembered, Van Gogh's Montmartre was a place where working-class folk liked "to cultivate their tiny pieces of sand in the early morning sun" (E. Bernard, "Vincent van Gogh," *Les Hommes d'Aujourd'hui* [Paris 1891]; reprinted in translation in Bogomila Welsh-Ovcharov, *Van Gogh in Perspective* [Englewood Cliffs, N.J. 1974] pp. 38–40, p. 38).
[2] Two of Van Gogh's favorite fictional women, the housemaid Germinie Lacerteux (protagonist of the Goncourt brothers' 1865 novel that bears her name) and laundress Gervaise Coupeau (of Zola's *L'Assommoir* [1877]) make this excursion with their sweethearts.
[3] One of the few known photos of the adult Van Gogh shows him sitting opposite Bernard at a table beside the Seine.
[4] Émile Bernard, preface to *Lettres de Vincent van Gogh à Émile Bernard* (Paris 1911); cited in translation in Hulsker 1996, p. 282.
[5] Compare Van Gogh's fairly contemporaneous *Wheatfield with a Lark* (Van Gogh Museum Amsterdam, F 310), where multitudinous horizontal dashes denote the heads of grain on wheat that grows on level ground.
[6] See, for example, F 293.
[7] Vincent to Wilhelmina van Gogh, June/July 1888 [W 1].
[8] Vincent to Wilhelmina van Gogh, autumn 1887 [W 1].
[9] Ibid.
[10] Vincent to Theo van Gogh, May 5, 1888 [482].

7 *Paysage avec de la neige*
Landscape with Snow

February 1888
Oil on canvas, 38.2 x 46.2 cm (15 $^{1}/_{16}$ x 18 $^{3}/_{16}$ in.)
New York, Solomon R. Guggenheim Museum
Thannhauser Collection, Gift, Hilde Thannhauser, 1984, 84.3239
F 290 JH 1360

Exhausted by the metropolis, Van Gogh decided in early 1888 to leave Paris and withdraw to southern France, where he sought a simple life, proximity to nature, and, above all, light and color. He also hoped to find stimuli like those he had found in Japanese woodcuts.

When he arrived in Arles on February 20, however, snow covered Provence. This limited his opportunities to work outdoors. Nevertheless, already by his second letter to his brother from Arles, Van Gogh was reporting: "...I have finished three studies, which is probably more than I could have managed in Paris these days. … The studies I've done are—an old Arlésienne, a landscape in the snow, a view of a bit of pavement with a pork-butcher's shop."[1]

The landscape with snow that he mentions may well have been this small study now in the Guggenheim Museum.[2] Since the letter quoted above can be dated to around February 24, the painting must have been executed in the first few days after Van Gogh's arrival. It shows the flat landscape outside the gates of Arles: the La Crau plain, with Montmajour rising abruptly above it. A road runs from the lower left corner into the middle of the painting. It creates a strong effect that draws the viewer's gaze into the background where the snow-covered mountain, trees, and a farm can be seen in the distance. A man walking with a dog comes into view in the broad, lonely plain.

The painter captured this motif in an extraordinarily simple composition. Three-quarters of the painting is occupied by the snow-covered fields. Tension results from the contrast between the plain, which spreads out across the width, and the road, which leads into the depth. The rhythm of the brushstrokes also emphasizes the horizontal and the diagonal. Long white and violet strokes depict the snow-covered fields, while short brown, green, and blue strokes on the road in the foreground suggest the slush and puddles that follow the melting of the snow. Strong vanishing lines, which in the foreground are worked up into yellow tufts of grass, mark the road bank. These forceful diagonals in the left half of the painting are contrasted with the short hatchings of the grass at front right, which run in the opposite direction.

The painterly hand in this study seems rushed and sketchlike. Accents of color are found especially in the foreground: green grass, the yellow road bank, and the brown, green, and blue nuances of the road. The middle ground is dominated by white, yellow, and violet hues, above which stands the cold, bright blue of the sky. The white mountain, the red roof of a house, and blue shadows place accents on the horizon. The isolated man walking his dog stands out, owing to his brown jacket and black hat, which both enlivens the composition and color of the painting and makes the loneliness of this winter landscape palpable.

Isolated figures on snow-covered fields appear already in Van Gogh's early work in Holland.[3] In *The Diggers* (F 695), from the series *Souvenirs du nord*, he also used this motif again later in Saint-Rémy.

D. H.

[1] Vincent to Theo van Gogh, about February 24, 1888 [464].
[2] Pickvance, in exh. cat. New York 1984, p. 43, was the first to associate the mention in Letter 464 with this painting, and convincingly so. De la Faille 1970 and Hulsker 1996, p. 306, by contrast, connect it with F 391 (cat. no. 8), since there is more snow there, while the snow in the present study has largely melted. Pickvance's examination of the meteorological reports of February 1888 in Provence shows, however, that the snow had indeed largely melted until new snow fell on February 25. On this painting, see also Vivian Endicott Barnett in coll. cat. New York/Guggenheim 1992, pp. 170, 171.
[3] See, for example, F 1232, F 1233.

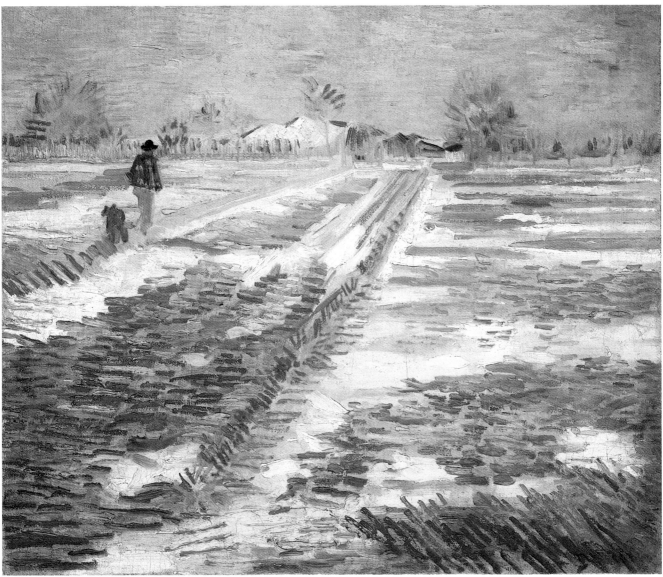

53

8 *Campagne blanchie avec la ville dans le fond*
Snow-Covered Landscape
with Town in the Background

March 1888
Oil on canvas, 50 x 60 cm (19 ³/₄ x 22 ³/₄ in.)
London, Private Collection
F 391 JH 1358

A few days after painting the small study of a winter landscape (F 290; cat. no. 7) Van Gogh told his brother around March 5, 1888 of another "study of a landscape in white with the town in the background."[1] The reference to the silhouette of the town of Arles makes it possible to identify that painting unequivocally with the present study. There appears to be more snow depicted here than in the first, smaller study. Because it was assumed that the snow progressively receded, Van Gogh's first mention of a snow landscape, in his letter of about February 24, was thought to refer to this painting.[2] By examining historical meteorological reports from Provence, however, Pickvance was able to establish that the snow had melted almost entirely by February 25, but then several centimeters of new snow fell, so that the different snow conditions represented by this particular sequence did indeed correspond to the weather at the time.[3]

It fits well with this discovery that the first snow landscape (cat. no. 7) is a small-format, rather ephemeral study, while this painting not only has a more ambitious format but is also worked out in a far more differentiated way. This also corresponds with the prominent signature that is worked into the motif of the wooden structure in the foreground. Even if these two studies are not preparatory studies for a large, finished painting, they can at least be seen as two different steps toward the subject of the snow-covered fields.

As in the first study of a snowy landscape, the snow-covered plain takes up three-quarters of the painting. The composition, however, is constructed quite differently. Here the artist dispenses with the vanishing lines that draw the viewer's glance rapidly into the depths; instead, he articulates the painting in horizontal layers with a very high horizon. The impetus for this was provided by the Japanese woodcuts that Van Gogh had valued so highly since his stay in Paris. He was already concerned with this idea in his first letter to his brother Theo from Arles: "And the landscapes in the snow, with the summits white against a sky as luminous as the snow, were just like the winter landscapes that the Japanese have painted."[4]

The bizarre branches of a bare tree, a green bush, and the strange straw-and-wood structure that probably represents the bulkhead of an irrigation channel establish a salient *repoussoir* in the foreground and at the same time represent the strongest color accent in the painting. The green and ochre are picked up again at the horizon, so that the foreground and background are bracketed. The middle ground in between is dominated by the snow-covered plain, which gets by without any particular motif. The use of white as a color was the central artistic task here, and for this too Van Gogh could find stimuli in Japanese woodcuts. There, however, the white paper ground is simply left alone; here he had to *paint* the white. Hence he structured the white plain with fluid, lively brushstrokes and indicated shadows and the structures of the land with several violet and light blue mixtures. The town of Arles can be seen in the far distance. The clear, light blue winter sky stands above it.

The composition, with its high horizon and the view of the town of Arles, would reappear frequently in Van Gogh's works in 1888, for example, in *Arles: View from the Wheat Fields* (F 545, fig. 5 p. 22), *Sunset: Wheat Fields near Arles* (F 465, fig. 3 p. 21), and *The Sower* (F 494).[5] In those paintings, however, he dispensed with the prominent motifs in the foreground and let the broad fields speak for themselves. Without any framing on the side or in front, he now dominated the giant expanse with the color and rhythm of his brushstrokes alone.

D. H.

[1] Vincent to Theo van Gogh, about March 5, 1888 [466].
[2] De la Faille 1970; see also Hulsker 1996, p. 306.
[3] Pickvance in exh. cat. New York 1984, p. 43, cat. no. 6.
[4] Vincent to Theo van Gogh, about February 21, 1888 [463].
[5] For the high horizon, see also the paintings in the harvest series of June 1888, especially F 411 (fig. 4), F 422 (fig. 7), F 561 (cat. no. 12), and F 564 (cat. no. 11).

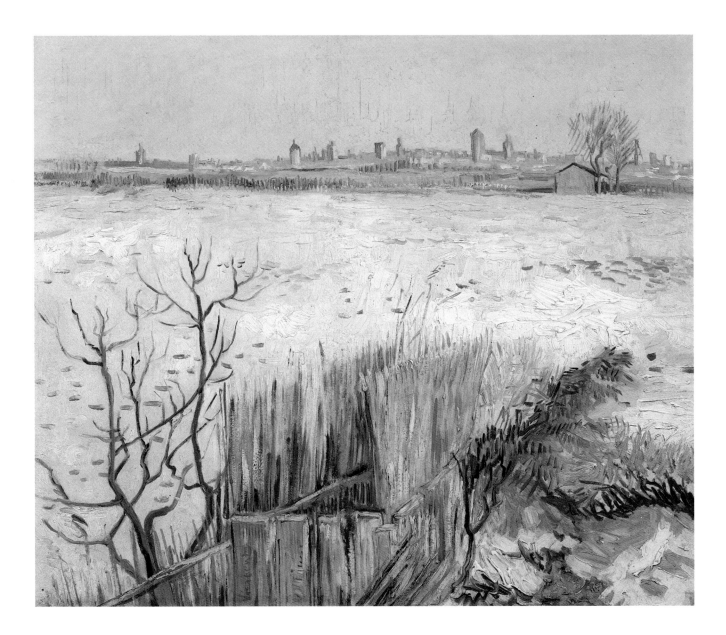

9 *Vue d'Arles, les iris*
View of Arles with Irises
in the Foreground

May 1888
Oil on canvas, 54 x 65 cm (21 1/4 x 25 9/16 in.)
Amsterdam, Van Gogh Museum (Vincent van Gogh Foundation)
s 37 V/1962
F 409 JH 1416

In March and April, Van Gogh painted the orchards in bloom (see cat. no. 7), then devoted his time during the following two weeks exclusively to drawing. It was not until May 12 that he informed Theo that he was working on two new studies in oil, for which he included letter sketches. One of these sketches is based on *View of Arles with Irises in the Foreground:* "A meadow full of very yellow buttercups, a ditch with irises, green leaves and purple flowers, the town in the background, some gray willows, a strip of blue sky. ... A little town surrounded by fields all covered with yellow and purple flowers; exactly—can't you see it?—like a Japanese dream."[1]

The central motif is the meadow and specifically its color. The purple irises in the foreground provide a complementary contrast to the meadow, while the orange roofs of Arles in the background and the tower of Saint-Trophime add another complementary contrast to the blue sky.[2] These contrasts are mediated by green. Visible behind the dark leaves of the lilies are the mowed strips of the meadow, rendered in light green interspersed with dabs of white and yellow, and beyond them the unmowed meadow in the luminous yellow of the buttercups. The willows along the road and the trees near the edge of the city take up the dark green of the lilies, while the turquoise trunks provide the transition to the blue of the sky.

Van Gogh made systematic use of different types of brushstrokes. Coarse, broad strokes and spots represent the blossoms and stalks of grass in the foreground. This technique is employed in the meadow as well. In contrast, the artist gave emphasis to the irises in a later phase of his work by adding delicate, dark blue contours. Thus blossoms and leaves are very sharply defined and exhibit an objective quality that contrasts with the broad painting style of the foreground and the meadow in the middle. The intense effect of these contours becomes evident in a comparison with several iris blossoms in the right foreground, which Van Gogh did not refine. The graphic element reappears in the background, where the portions of the silhouette of the city and the trees are rendered with breathtaking precision in dark blue lines that provide a strong contrast to the broad impasto strokes of the sky. In this way, Van Gogh established the link between foreground and background through both color and artistic technique.

At first glance, the composition appears clear and simple, arranged in strips in accordance with the classical sequence of foreground, middle ground, and background. But the plane of the field is not perpendicular to the viewer's gaze; instead, the artist presents a diagonal view. The irises, the mowed strips of meadow, and the prominent boundary along the yellow field of flowers are arranged toward a vanishing point that lies to the left, beyond the frame of the painting. The irises in the foreground suggest the presence of the outermost corner of the meadow at this point. The opposite corner can be seen where the road makes a barely perceptible turn behind the third tree from the left.

"If the meadow does not get mowed, I'd like to do this study [i.e., this painting] again," wrote Van Gogh to his brother, "for the subject was very beautiful, and I had some trouble getting the composition."[3] He had already learned how complicated the configuration of spatial depth in the painting would be while working on a reed-pen drawing of the meadow shortly before executing the oil study (F 1416); pencil lines clearly indicate that he used a perspective frame.[4] The composition of the oil study is simpler and more clearly defined than that of the drawing, due in part to the fact that more of the meadow had been mowed by the time he began the painting.[5] Yet it may well have been a purely artistic consideration that prompted him to construct a clear line out of the irregularly mowed strips as a parallel to the line of irises along the ditch. A similar process leading to greater uniformity of the fields appears to have taken place between the drawing and the painting of *Field with Poppies* (cat. no. 13).

D. H.

[1] Vincent to Theo van Gogh, about May 12, 1888 [487], including a sketch of the painting, compare JH 1418.
[2] Compare Pickvance, in exh. cat. New York 1984, cat. no. 27; exh. cat. Rome 1988, cat. no. 29; Pickvance, in exh. cat. Martigny 2000, cat. no. 52.
[3] Vincent to Theo van Gogh, about May 12, 1888 [487].
[4] Compare Pickvance, in exh. cat. New York 1984, cat. no. 26, pp. 66, 67. See also Stiles Wylie 1970, pp. 220, 221, ill. p. 233.
[5] Van Gogh mentioned this in a letter to Émile Bernard written during the latter half of May 1888 [B 5]: "They were mowing while I was painting, so it is only a study and not the finished picture that I had intended to do."

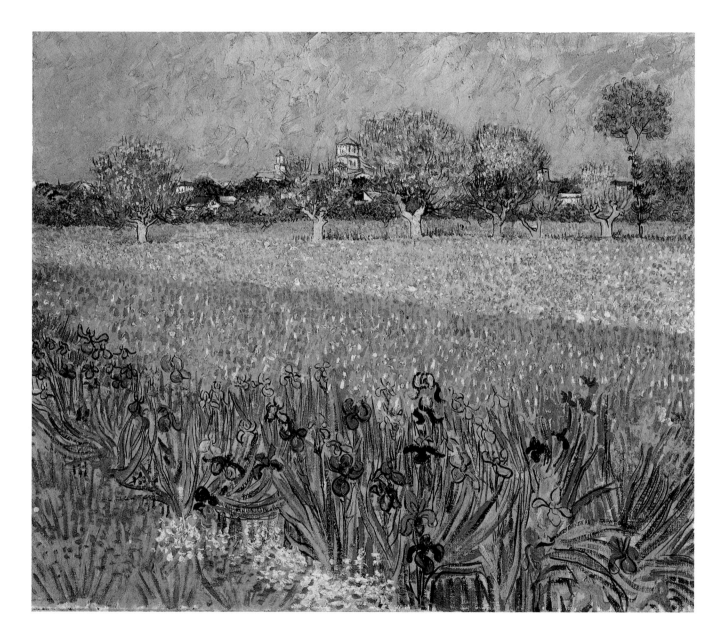

11 Wheat Field, from the series "La moisson en Provence"

June 1888
Oil on canvas, 50 x 61 cm (19 11/$_{16}$ x 24 in.)
Amsterdam, Stichting Collectie P. en N. de Boer
F 564 JH 1475

The oil study *Wheat Field* is one of six small works from the harvest series that Van Gogh painted in June 1888 in La Crau, before the gates of Arles (see also cat. nos. 10 and 12 and figs. 4–6 p. 22).[1] The motif, however, is related to one of the three large paintings from this harvest series, *Harvest at La Crau with Montmajour in the Background* (F 412, fig. 1 p. 21). The tall white farmhouse seen on the right edge of the large painting is on the left half of this small oil study, while the view over the plain is continued on the right. Unlike in *Harvest at La Crau,* the artist dispensed with depicting people and harvest vehicles, and he does not steer the viewer's glance as much into the distance but instead concentrates it, stripped of all narrative details, on the ripe wheat field that lies immediately before him.

The field takes up about two thirds of the picture surface. Salient motifs like the farm houses, the haystacks, the hedges, or the trees are visible only in the distance, with the blue procession of the Alpilles and the sky above. The artistic challenge lay above all in managing the great expanse of this wheat field. A decisive aspect of the construction of the perspective is the strong diagonal that separates the stubble field in the foreground from the wheat field behind it. Also contributing to the articulation is the mowed area on the right side of the painting, by means of which the opposed diagonal is introduced into the composition. The depth that can be read in this way is underscored by the depiction of the stubble and the wheat. The stubble in the foreground forms large, powerful bundles of brushstrokes but only short individual strokes in the background, and the wheat, which in the foreground is differentiated in form and color of brushstrokes, fuses into an expanse of colorful impasto further back.

The contrast between the blue-violet sky and the orange-yellow field dominates the effects of color. Only the farmhouse, with its orange roof, brackets these two areas, which are also sharply distinct in the style of painting. Thus the sky is executed with more fluid paint in broad horizontal strokes, while the field consists of short vertical strokes and dabs that produce their own rhythm, which suggests the movement of the stalks. By means of this rhythm and the diagonals the artist has structured and articulated the wide expanse of the field. The field in *Farmhouse in Provence* (cat. no. 10), by contrast, remains a largely undifferentiated expanse. For that reason, it may be assumed that this study was completed only after *Farmhouse in Provence.*

It is difficult to reconstruct the exact sequence of the paintings in the harvest series.[2] On the basis of the large expanse of wheat that is still standing, it may be assumed, however, that *Wheat Field* belongs with *Farmhouse in Provence* and the large painting *Harvest at La Crau* (F 412), among the first works in the series. The second group probably includes, among others, *Harvest in Provence* (F 558, fig. 6 p. 22), in which the color contrast is more intense and the sketch-like, rhythmic brushstroke is further developed. This is made more clear by comparing a detail: where in the present study green and brick-red strokes mark the shadowy, weed-filled area at the edge of the wheat field, in the painting *Harvest in Provence* this zone has red and green strokes right next to each other. The color and pictorial effect are more important in the later painting than is the differentiated depiction of the object.

D. H.

[1] On the harvest series, see Dorn 1997/98, pp. 20, 21, and Dorn 2000, pp. 34–41.
[2] On the dating, see Pickvance, in exh. cat. New York 1984, p. 98; Dorn 1997–98, p. 20; Dorn 2000, p. 38.

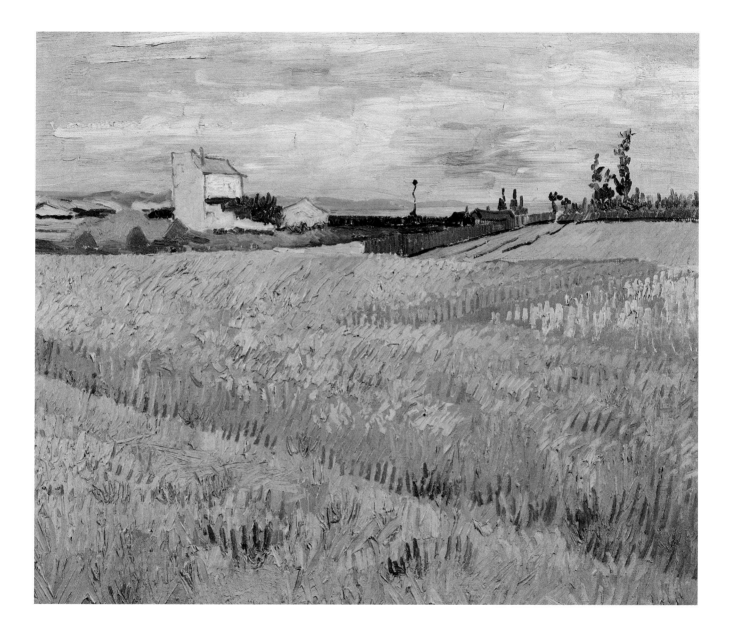

12 Wheat Field: The Sheaves, from the series "La moisson en Provence"

June 1888
Oil on canvas, 55.2 x 66.7 cm (21 3/4 x 26 1/4 in.)
Honolulu, Honolulu Academy of Arts
Gift of Mrs. Richard A. Cooke and her Family in memory
of Richard A. Cooke, 1946 (377.1)
F 561 JH 1480

The painting *Wheat Field: The Sheaves*[1] is one of the six smaller oil studies of the harvest series "La moisson en Provence" that Van Gogh painted in June 1888 (see also cat. nos. 10 and 11 and figs. 4–6 p. 22).[2] Unlike *Wheat Field* (cat. no. 11), in which a diagonal determines the foreground, the structure of this work is entirely horizontal. Half of the painting is taken up by a stubble field on which several sheaves have been stacked. Comparable to the metaphor-laden figures of the sower and the reaper, the sheaves become the main motif of the painting. For Van Gogh they were like "the magic of hosts of memories of the past, of a longing for the infinite, of which the sower, the sheaf are the symbols...."[3] Like the motifs of the sower and the reaper, this motif occupied him again and again. As early as 1885 he had sketched sheaves on a field many times, and in July 1890 in the context of a cycle on rural life he painted them in his new, extended square format.[4]

In this oil study from the harvest series, only the sheaves break through the horizontal pictorial structure and thus bridge the foreground and middle ground, where the ripe grain is still on the stalk. The stripelike arrangement of the fields in the distance, in which stubble with sheaves alternates with green meadows up to the horizon, does not intersect with the sheaves. The two trees that jut above the horizon into the sky were added in a later phase of work, after the painting had largely dried already.

The painting style seems light and sketchlike in the foreground. Against a violet ground Van Gogh has placed in a loose distribution the short, yellow strokes of the stubble, which at greater remove become tufts. The open, draftsmanlike way in which the stubble and sheaves have been outlined stands in contrast to the sky and clouds, which are reproduced with more fluid paint in soft, broad strokes. The movement of the clouds nevertheless establishes a relationship to the living bunches of the wheat stalks. The shadow cast by the sheaves is presented in powerful brownish strokes punctuated with red. They find a response on the horizon in the roofs of the houses.

The painting style, which is sketchlike on the one hand but very fluid on the other, leads one to suspect that this painting is probably not one of the first oil studies in the harvest series but was probably completed toward the end of that group of works. In contrast to the technique still found in *Farmhouse in Provence* (cat. no. 10), here the artist dispensed with a preliminary drawing and worked directly with brush and oil paint on the canvas. He told his friend Émile Bernard of a new, rapid style of painting: "I have seven studies of wheat fields, all of them landscapes unfortunately, very much against my will. The landscapes yellow—old gold—done quickly, quickly, quickly and in a hurry, just like the harvester who is silent under the blazing sun, intent only on his reaping."[5]

Although Van Gogh dispensed with a preliminary drawing for this painting, in July and August he completed two drawings *after* this oil study.[6] The first of these (F 1488) is a coarse sketch with a reed pen in which the stubble, the sheaves, and the fields are even more strongly rhythmic in their strokes and more lively than in the model. The second one (F 1489), which Van Gogh sent to artist John Peter Russell, shows how Van Gogh "translated" the color nuances of the oil study to the drawing by means of heavier or more delicate dabs and dots. On this sheet he supplemented a reed pen with a fine drawing pen, with which he worked out the background more precisely.

Both drawings belong to whole series of works in which Van Gogh transferred his own oil studies into another medium and thus made his own hand more precise and at the same time more stylized. They reveal the great possibilities for variation that were all simultaneously available to him in reproducing a single motif. This makes it all the more visible how consciously he employed his artistic means, not—as the Van Gogh myth would have us believe—simply pouring his emotions onto the canvas or sketching paper in the agitated state of a genius.

D. H.

[1] On this painting, see Pickvance, in exh. cat. New York 1984, cat. no. 47; Van Tilborgh, in exh. cat. Amsterdam 1989, cat. no. 23; and Van Tilborgh, in exh. cat. Paris 1998/99, cat. no. 17.
[2] On the harvest series, see Dorn 1997/98, pp. 20, 21, and Dorn 2000, pp. 34–41.
[3] Vincent van Gogh to Émile Bernard, about June 22, 1888 [B 7].
[4] For example, F 1319v and F 809.
[5] Vincent van Gogh to Émile Bernard, about June 25, 1888 [B 9].
[6] On the drawings, see Pickvance, in exh. cat.. New York 1984, pp. 124–127, cat. nos. 67 and 76.

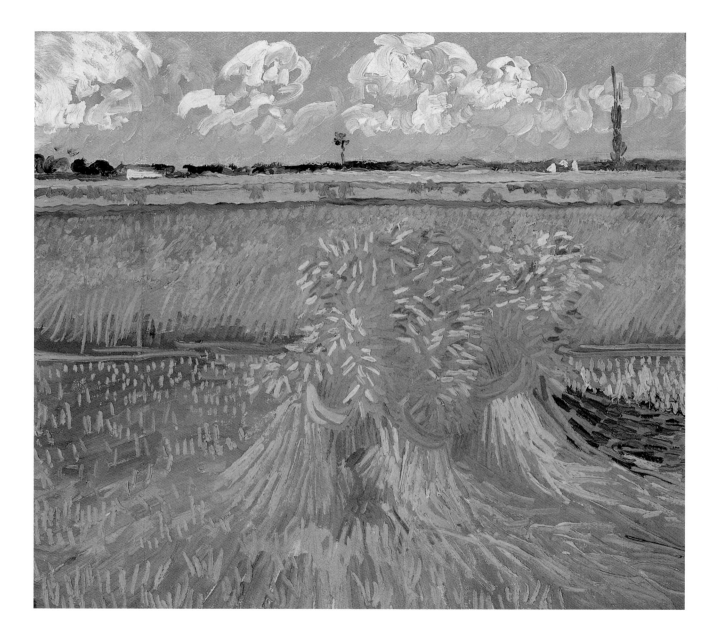

13 *Champ de blé, les coquelicots*
Field with Poppies

June 1889
Oil on canvas, 72 x 91 cm (28 3/8 x 35 13/16 in.)
Bremen, Kunsthalle Bremen
Acquired with the assistance of the Galerieverein, 1911, 319-1911/1
F 581 JH 1751

On May 8, 1889, Van Gogh admitted himself to the Saint-Paul-de-Mausole asylum in Saint-Rémy. For four weeks he was required to stay in the asylum and its grounds. In early June he was permitted to work outside the walls of the hospital, and this poppy field was one of the first subjects he painted.[1] The point of departure for this work is the view across the valley immediately behind the hospital. At first glance the painting suggests great distance. The yellow wall, the bright red poppies bordering the field, and the dark furrows of the wheat field together generate a sense of perspective that draws the viewer into the depth of the scene, where the perspective lines converge at a vanishing point just beneath the upper edge of the painting. It is here, precisely where one would expect to find the sky extending the view into the distance, that the viewer's gaze is blocked by the rising hills. Thus the sense of depth is revealed as an illusion, and the viewer is called back to the flat surface of the canvas. This fundamental structural paradox[2] reflects two themes with which Van Gogh was particularly concerned in Saint-Rémy: close-up observations of his immediate surroundings, which we find in his skyless pictures from the hospital garden (compare cat. no. 17) and the view into the distance from his bedroom window (compare figs. 8 and 9 p. 27).

The extent to which Van Gogh departed from reality in his painting also becomes evident, for the real terrain does not rise but describes a continuous downward slope. Thus the painter drew inspiration from a landscape he actually saw in order to create a painting according to rules of his own making. This is also apparent in the rigorous composition. The two yellow houses and the vertical lines of a few trees in the background set clear lateral accents. The artist found them so important that he added the house and cypresses on the right although they were not actually there. The three dark-green trees in the foreground form a classic repoussoir element. They stand below the viewer and cast dark shadows on the field. Because they are seen from high above, their position in space is difficult to read. The result is that here—as in the background—the illusion of spatial depth is counteracted by energetic brushwork that emphasizes the surface of the canvas.[3]

The painting was executed in several successive layers.[4] Van Gogh applied his colors in thin paint over a sketch done in blue and brown, which is still visible in some places. The tree on the far left in the foreground and the dark-green shadow along the right edge were both painted during this phase, and Van Gogh made very few changes to them as his work progressed. He then applied the thicker areas, which are distributed over the entire surface. The layers are most heavily concentrated in the central, dark green field, the tree on the right, and the hedge that borders the field on the right. The dense fabric of brushstrokes gives the structures of the tree, the field, and the bushes an almost tactile quality. This particular area also plays a very important part in the development of perspective and the color scheme, which relies on the complementary contrast of red and green. The paint grows thinner toward the edges of the painting (as can be seen in the tree on the far left). In other places, patches of unpainted, sized canvas remain exposed, as in the house on the left, where areas of heavy impasto appear immediately alongside unpainted spaces.

Given its complexity and the step-by-step process Van Gogh employed in executing this painting, it is not surprising that he prepared a preliminary drawing for the work (F 1494). *Field with Poppies* was presumably conceived as a counterpart to *Mountainous Landscape behind Saint-Paul Hospital* (F 611, fig. 8 p. 27). Its coloration, composition, and subject present a marked contrast to that painting, which is essentially devoted to the same subject—fields. Yet although he dealt with the theme of *Mountainous Landscape behind Saint-Paul Hospital* in an entire series of works, *Field with Poppies* is the only painting featuring this particular motif, and its only precedent is the drawing. Van Gogh mentioned *Mountainous Landscape behind Saint-Paul Hospital* often in his letters, but we find no reference at all to *Field with Poppies*. Before sending the painting to his brother in September 1889, he listed it as a "study of fields," describing it as one of those "...studies without the effect of a whole that the others have."[5] It was not until October, when he actually sent the painting off, that he referred to it as "poppies."[6]

D. H.

[1] "I am working on two landscapes (size 30 canvases), views taken in the hills...." wrote Vincent to Theo van Gogh on about June 9, 1889 [594]. He described the one picture as *Mountainous Landscape behind Saint-Paul Hospital* (fig. 8 p. 27). A review of the surviving paintings suggests that the other was *Field with Poppies*.
[2] This structure is presumably one of the reasons for the divergent assessments of this painting. It seems to me that too much emphasis is placed on traditional aspects in exh. cat. Amsterdam 1990, cat. no. 87. See also Dorn, in exh. cat. Essen/Amsterdam 1990/91, cat. no. 38, who first pointed out the possibility of *Mountainous Landscape* as a pendant; Pickvance, in exh. cat. New York 1986/87, cat. no. 9; exh. cat. Copenhagen 1984/85, cat. no. 74.
[3] This is also discussed by Gustav Friedrich Hartlaub (1911), whose analysis of *Field with Poppies* is still one of the best.
[4] I wish to thank conservator Barbara Wiemers for her remarks on the painting process.
[5] Vincent to Theo van Gogh, about September 19, 1889 [607].
[6] Vincent to Theo van Gogh, about October 5, 1889 [608].

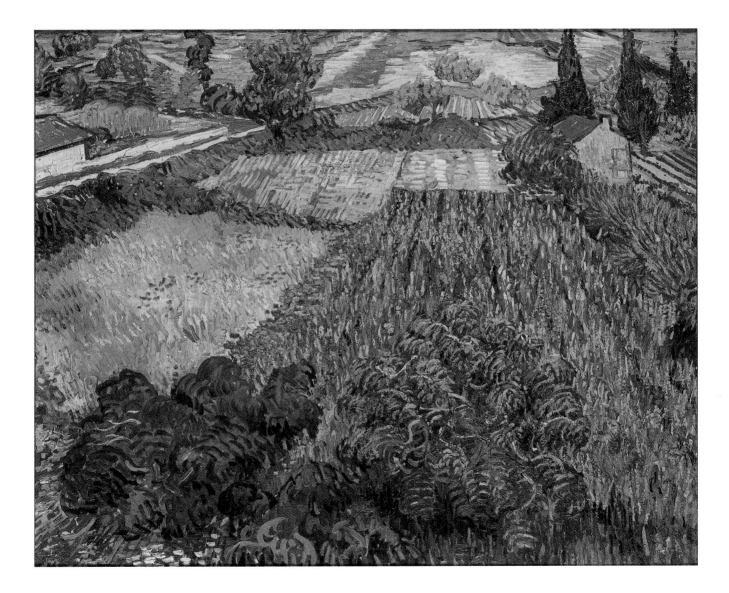

15 *Champ labouré, avec fond de montagnes*
Plowed Field with Mountains in the Background

October 1889
Oil on canvas, 73.7 x 92.1 cm (29 x 36 1/4 in.)
Indianapolis, Indianapolis Museum of Art
Gift of Mrs. James W. Fesler in memory of Daniel W. and
Elizabeth C. Marmon, 44.74
F 641 JH 1795

In a letter to his brother, Theo, soon after his arrival in Saint-Rémy Van Gogh described the view from his bedroom: "through the iron-barred window I see a squarefield of wheat in an enclosure, a perspective like Van Goyen, above which I see the morning sun rising in all its glory."[1] In a series of nine compositions during the course of his one-year stay at Saint-Rémy, he depicted the wheat field after a storm (F 611, fig. 8 p. 27), with a reaper (F 617, fig. 9), in moonlight (F 735, fig. 10), during plowing (F 625), in rain (F 650, fig. 11), at sunrise (F 737), and as a green field interspersed with poppies (F 718 and F 720, fig. 12)

Plowed Field with Mountains in the Background belongs to this series. To a greater extent than in any of the other paintings of this walled field, the artist's perspective here is turned toward the southeast, so that the wall on the right and the tract of land rising in front of it becomes a salient motif. While elsewhere Van Gogh concentrated his attention on the fundamentals of field, wall, mountains, and sky—and sometimes simplified these motifs a great deal—here he depicts numerous topographical details. In the foreground stands a thistle from which a path leads into the painting toward the right, where a farmer is carrying a bundle of straw; the diagonal line of the path intersects a rise on which a stack of straw can be seen. Beyond the walls, farms, fields, and olive trees can be distinguished on the rising hills, behind which the bluish cliffs of the Alpilles loom up.

Van Gogh himself described the painting at length in mid-October 1889 in a letter to his brother: "I have just brought back a canvas on which I have been working for some time, representing the same field again as in the 'Reaper.'… It is again a harsh study, and instead of being almost entirely yellow, it makes a picture almost entirely violet. Broken violet and neutral tints. But I am writing you because I think this will complement the 'Reaper' and will make clearer what that is. For the 'Reaper' looks as though it were done at random, and this will give it balance."[2]

The painting, which was completed in several sessions before the motif, reveals a rough, sketchy hand. Van Gogh referred to such initial encounters with a motif in nature as "études." Often he would later paint a reworked version, a "tableau," in which he sharpened the composition and stylized the brushwork. There is, however, no such second version of *Plowed Field with Mountains in the Background*.

It is typical of Van Gogh's way of thinking and working that he related paintings to one another as series or counterparts.[3] He saw *Plowed Field* as a pendant to the painting *Wheat Field: The Reaper,* on whose three versions he had been working just before this, in September and October.[4] Not only do these paintings reproduce a very similar landscape motif, but the first version is also executed in a related raw, sketchy painting style. Moreover, both oil studies reveal the small figure of a laboring farmer, which is not found in the other paintings in the series with a walled field.[5] They are related to each other in size and composition, but the artist does not say more about their possible metaphorical connection. Hence it seems better to view it primarily as depicting farm work in the rhythm of the year,[6] such as had already been depicted in the work of Jean-François Millet. In lieu of Millet's figure paintings, Van Gogh paints landscapes with subordinate figures.

In terms of motif, composition, painting style, and the role of figures, *Wheat Field: The Reaper* and *Plowed Field* are very similarly constructed, so that their charm for the viewer lies in observing the fine differentiations. The respective palettes of these counterparts are, however, strongly contrasted. Both works are based on a scale of related hues: in one case yellow dominates; in the other, violet; the pendants thus produce a complementary contrast that intensifies the effect of each painting.

D. H.

[1] Vincent to Theo van Gogh, about May 25, 1889 [592].
[2] Vincent to Theo van Gogh, about October 15, 1889 [610]. The same day he described the painting, if not quite as extensively, in a second letter to his friend Émile Bernard [B 20].
[3] In another letter to Theo about January 3, 1890 [621], Van Gogh emphasized that he saw the paintings as counterparts. On the theme of series and pendants in Van Gogh's work, see Dorn in exh. cat. Essen/ Amsterdam 1990, p. 36, and Dorn 1990, esp. pp. 72ff. and 101ff.
[4] In June–July, September, and October 1889 Van Gogh painted three versions of *Wheat Field: The Reaper:* the "étude" (F 617, here fig. 9), the "tableau" (F 618), and a reduced repetition (F 619). The "étude" should probably be seen as the counterpart to *Plowed Field.*
[5] Only in the two versions of *Plowed Field* (F 625 and F 706 here cat no. 14) are there figures, but they are significantly smaller.
[6] On the metaphorical aspect, see exh. cat. Amsterdam 1990, p. 221, cat. no. 96, and Noll 1994, p. 131.

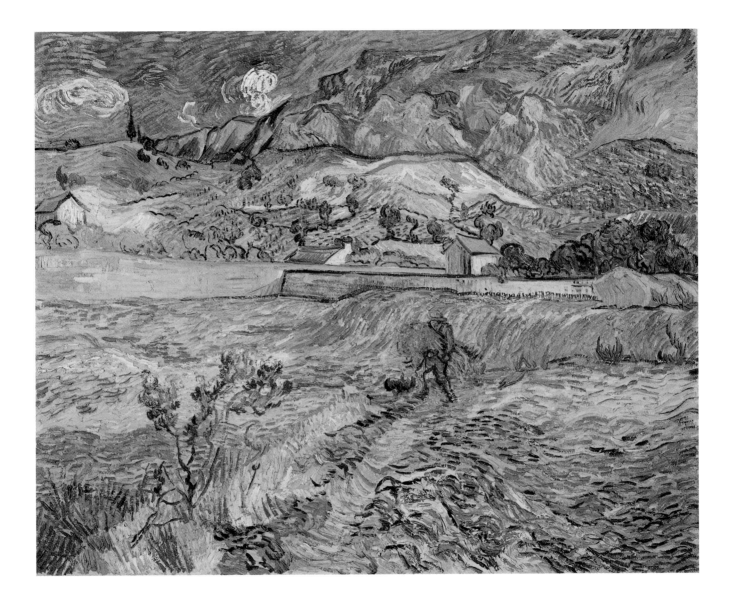

16 *Les premiers pas*
The First Steps,
after Jean-François Millet

January 1890
Oil on canvas, 72.4 x 91.1 cm (28 $^1/_2$ x 35 $^7/_8$ in.)
New York, The Metropolitan Museum of Art
Gift of George N. and Helen M. Richard, 1964, 64.165.2
F 668 JH 1883

A farmer has stopped working and laid down his spade. He
kneels on the ground with outstretched arms and awaits the
child, who wants to walk toward him but is still supported by its
mother. The title reveals what is about to happen: the child is about
to take its first steps toward its father. An emotional episode in the
life of a family is depicted, a situation in which joy in recognition of
a child's development is expressed in a dialogue of gestures and body
language. The painting shows an intact world. The father works in
the field near the house. The mother does the washing and hangs it
on the fence. And she tends to the child. Life and labor form an
integrated framework for the happy family.

The First Steps is a genre picture, something one might not normally
expect in Van Gogh's oeuvre. Although the scene takes place in a summer
garden landscape, the figures and the narrative are the most important
elements. It is this that distinguishes the painting from Van Gogh's
landscapes with fields from the period 1888 to 1890, in which human
figures are either subordinated to the landscape or entirely absent from it.

The composition is actually not Van Gogh's. He painted this picture
from an original by Jean-François Millet, whose works he greatly
admired for their emotional and symbolic power. Millet's *Sower*
had attracted his attention very early in his career as a painter, and he
returned to the subject in Arles (see fig. 7 p. 24). During the autumn
and winter of 1889/90 he painted a total of twenty pictures based
on works by Millet. *The First Steps* belongs to a series of six large
paintings based on Millet's *Four Hours of the Day: Morning: Peasant
Couple Going to Work* (F 684), *Noon: Rest from Work* (F 686), *Evening:
The End of the Day* (F 649), and *Evening: The Watch* (F 647).[1] The
last two are *The Plow and the Harrow* (F 632) and *The First Steps*.

Van Gogh worked from reproductions. In a letter written about
October 23, he thanked Theo for a shipment of source material,
which included a photograph of Millet's *The First Steps*.[2] Yet he did
not begin work on the corresponding painting until January 1890:

"This week I am going to start on the snow-covered field and Millet's
'The First Steps,' in the same size as the others. Then there will be
six canvases in a series, and I can tell you, I have put much thought
into the disposition of the colors while working on these last three of
the 'Hours of the Day.'"[3]

Van Gogh had already explained his interest in copying to his brother
in September 1889. He wrote that copying gave him an opportunity
to paint figures, as he had no models in Saint-Rémy.[4] But he did not
regard these works as simple copies done for learning purposes. He
saw them as improvisations based on originals by highly esteemed
masters. Although he ordinarily reproduced the composition quite
precisely, he developed his own coloration as he transposed the black-
and-white sources into the medium of colored canvas paintings.
"Working thus on his drawings or on his woodcuts is not purely and
simply copying. Rather it is translating—into another language—that
of color—the impressions of light and shade in black and white."[5]
He immersed *The First Steps* in a radiant spectrum of yellows, greens,
and blues that underscore the sense of joy associated with the event.

Van Gogh's improvisations on Millet are closely related to the field
theme to which he devoted much of his attention in Saint-Rémy.
Fields being plowed and harvested serve as settings for Millet's human
figures. The farm labor reflects changes of time, seasons, and the
weather—aspects which also play an important role in Van Gogh's
straight landscapes. The six large figurative paintings based on works
by Millet, of which *The First Steps* is one, thus become a counterpart
to the series of landscapes in which Van Gogh depicted the enclosed
field. With his improvisations on Millet, he professed his interest in
the tradition of metaphor-laden genre painting, while his own
compositions were modern landscapes in which figures and concrete
metaphors were largely absent or secondary. They remained alive in
his thoughts, however, as he expressed in the literary form of his letters.

D. H.

[1] See the detailed discussion by Van Tilborgh, in exh. cat. Paris 1998/99, pp. 120–159,
esp. cat. no. 80, pp. 152, 153; Dorn, in exh. cat. Essen/Amsterdam 1990/91, cat. no. 51,
pp. 160–164; Pickvance, in exh. cat. New York 1986/87, cat. no. 46, pp. 172–173;
Homburg 1996, pp. 85–92; and Chetham 1960, p. 190.
[2] Vincent to Theo van Gogh, about October 23, 1889 [611].
[3] Vincent to Theo van Gogh, January 1890 [623].
[4] Vincent to Theo van Gogh, about September 19, 1889 [607].
[5] Vincent to Theo van Gogh, January 1890 [623].

17 *Coin de prairie ensoleillée*
Meadow in the Garden of Saint-Paul Hospital

April–May 1890
Oil on canvas, 64.5 x 80.7 cm (25 3/8 x 31 3/4 in.)
London, National Gallery
Inv. 4169
F 672 JH 1975

By late April 1890, Van Gogh had recovered from the longest and severest attack of illness he had yet suffered during his stay at the Saint-Rémy hospital. "...my work is going well, I have done two canvases of the fresh grass in the park," he reported to Theo on about May 4.[1] He provided a sketch of one (F 676),[2] and the other is presumed to have been *Meadow in the Garden of Saint-Paul Hospital.*[3] The sketch depicts a meadow covered by a carpet of flowers with two huge tree trunks in the left foreground. In the present painting, however, Van Gogh concentrated solely on the grass and the small butterflies. This restriction to unpretentious detail posed the greatest challenge of all for the artist.

He forces the viewer to gaze at the ground. The frame of view is sharply bordered toward the top but is open and infinitely extendable on either side. Using a palette of green, ochre, yellow, and white tones interspersed with areas of purple, the painter rendered the grass in fine brushstrokes that form bundles like the vegetation itself. Originally, there may also have been red accents (applied in red lake), which have since faded. A sense of three-dimensional space is evoked by the path and the trunk of a tree along the upper edge of the painting and above all by the size of the blades of grass—the length of the brushstrokes. The meadow of flowers seen in the distance in the upper third of the painting is suggested merely by short hatchings and dots. Here, the artist has designed a picturesque cosmos comprising delicate gradations of color and diverse graphic abbreviations—an image that turns a plain patch of grass in the sun into a living natural detail.

In this close-up view, Van Gogh achieves an impression of depth that comes very close to that evoked in his pictures of distant fields. As in *Field with Poppies* (cat. no. 13), there is no horizon and no sky; the path along the upper left-hand edge of the painting is a crucial element in the construction of spatial depth. Above all, however, the painting has the effect of an answer to the *Field of Spring Wheat at*

Sunrise (F 720, fig. 12 p. 27), which he also completed during these last days at the hospital. It looks like an enlarged detail from the foreground of that painting, and it creates a painter's argument out of the analogy of microcosmos and macrocosmos.

The idea of focusing on a blade of grass was a product of Van Gogh's understanding of Japanese culture, which he had developed primarily through reading. The wise Japanese man was not concerned with astronomy or politics, he wrote in a letter to Theo in September 1888. "No," he added, "he studies a single blade of grass. But this blade of grass leads him to draw every plant and then the seasons, the wide aspects of the countryside, then animals, then the human figure. ... Come now, isn't it almost a true religion which these simple Japanese teach us, who live in nature as though they themselves were flowers?"[4]

In a formal sense, however, Van Gogh's *Meadow in the Garden of Saint-Paul Hospital* has nothing in common with Japanese art. It is embedded in an entirely European tradition and calls to mind the oil sketches of Romantic painters who worked systematically on two specific problems: the detailed sketch of a scene viewed from close up and the panoramic view from a distance. In this work, Van Gogh creates a veritable tableau with a monumental spatial effect from a detail study.

D. H.

[1] Vincent to Theo van Gogh, about May 4, 1890 [631].
[2] Letter sketch in [631]; compare JH 1971.
[3] Compare exh. cat. Ottawa 1999, pp. 14, 15. See also exh. cat. Rome 1988, cat.no. 44; Pickvance, in exh. cat. New York 1986/87, p. 183. For an interpretation of the butterflies, see Noll 1994, p. 141.
[4] Vincent to Theo van Gogh, about September 24, 1888 [542]. Van Gogh had seen a reproduction of a drawing of a single blade of grass by Hokusai that prompted this remark. Compare coll. cat. Amsterdam 1991a, fig. 40.

73

18 Houses at Auvers

June 1890
Oil on canvas, 61 x 73 cm (23 5/8 x 28 3/4 in.)
Toledo, Toledo Museum of Art
Purchased with funds from the Libbey Endowment,
Gift of Edward Drummond Libbey, 1935.5
F 759 JH 1988

In the the autumn of 1889 at the asylum in Saint-Rémy, Van Gogh began to consider returning to the north, and May 16, 1890, he left, after arranging to move to Auvers-sur-Oise. It would be the extensive plains above Auvers that ultimately captivated his attention in such paintings as cat. nos. 23–27, but Van Gogh initially turned his eye on the village itself. "Auvers is very beautiful, among other things a lot of old thatched roofs, which are getting rare. ... for really it is profoundly beautiful, it is the real country, characteristic and picturesque," he wrote Theo (and Theo's wife, Jo) in his opening letter to them after his arrival in Auvers on May 20, 1890.[1] His next letter mentions his first painted study since his departure from Saint-Rémy, one of thatched roof cottages, a subject that frequently occupied Van Gogh during his seventy days in Auvers, just as it had during his years in Brabant at the outset of his career.[2]

On Tuesday June 10, two days after Theo and his family had visited Van Gogh in Auvers, he wrote his brother and sister-in-law, "Since Sunday I have done two studies of houses among the trees."[3] *Houses at Auvers*, initially owned by Andries Bonger, Theo's brother-in-law, is commonly thought to be one of these paintings.[4] Working in a hamlet called Chaponval, located in the western part of Auvers, Van Gogh painted a cluster of dwellings nestled amid walled gardens and trees silhouetted against a gray-blue, cloudy sky. Identifiable as still existing (though now altered) homes along the rue de Gré, the central structure was known as "la maison du Père Lacroix," the house of Auguste Lacroix, a mason, and had been the subject of a painting by Paul Cézanne in 1873.[5] The juxtaposition of its blue tiled roof with the contiguous thatched roofs doubtless intrigued Van Gogh, and he even made a reference to such a comparison in one of his letters.[6]

Van Gogh structured his composition as a series of horizontal zones demarcated by diagonals. In the lower right corner he included a small grassy patch accented by red poppies. Just behind appears a stone wall extending the width of the canvas, which encloses a garden in which white roses bloom and grape vines grow much as they do in other works from exactly this time.[7] Houses receding to the left, trees to the

right, and pockets of sky complete the composition. Noteworthy within this pattern is the directional variance of the brushstrokes. The roof of the central white house is executed with sideways strokes to mimic the appearance of its tiling, while the adjacent thatched roof is rendered with downward gestures to convey its own material. In contrast, the vegetation throughout is accomplished with Van Gogh's typical curvilinear, animated forms. Moreover, the heavily impastoed roofs, vines, and branches offer a distinct contrast to passages left untouched, such as the contour of the main house at its lower left, or ones of smoothly applied paint as is the case with the white vertical band prominently positioned in the very center of the picture on the façade of the upper level. Lastly, bounding contour strokes in Prussian blue were put down late in the creative process.

In the very same letter in which Van Gogh is thought to have cited the present painting, he also writes of his satisfaction in being closer to Theo. He continues, "I hope that we shall often see each other again. ... I should very much like you two to have a pied à terre in the country along with me."[8] It is not implausible that Van Gogh harbored the desire to live in such a place as painted here, one that would have provided ample accommodation for sought-after visits from his brother, sister-in-law, and like-named nephew.[9] Such a wish may even have provided to some degree the impetus to depict settings the likes of *Houses at Auvers*. In fact, the next occasion for Theo to find himself in Auvers was at the side of his brother's deathbed.

L. W. N.

[1] Vincent to Theo van Gogh and Johanna van Gogh-Bonger, about May 20, 1890 [635]. See also his first letter from Auvers to his sister Wilhelmina, about May 20, 1890 [W 21], "Here there are moss-covered thatched roofs which are superb, and which I am certainly going to do something with."
[2] Vincent to Theo van Gogh and Johanna van Gogh-Bonger, about May 21, 1890 [636]. His first Auvers canvas can be identified as F 750. For others of the subject, see F 758, F 780, F 792, F 793, and F 806, as well as the watercolor F 1640r, in addition to the present example.
[3] Vincent to Theo van Gogh and Johanna van Gogh-Bonger, about June 10, 1890 [640].
[4] Scherjon and De Gruyter, p. 319; Rewald 1996, p. 374; De la Faille 1970, p. 293; Arikawa, in exh. cat. Tokyo 1985, p. 245; and Pickvance, in exh. cat. New York 1986/87, pp. 206, 235. A dating to late May is preferred by Hulsker 1986, p. 457; and exh. cat. Detroit/Philadelphia/Boston 2000, p. 179. The second study is variously given as F 792 or F 758.
[5] Rewald 1996, no. 201. See also Gachet 1994, pp. 119–120, p. 80 n. 17, and p. 176 n. 71; and Machotka, p. 40.
[6] Vincent to Theo van Gogh and Johanna van Gogh-Bonger [636] (see note 2 above): "But I find the modern villas and the middle-class country houses almost as pretty as the old thatched cottages which are falling into ruin."
[7] See for example F 1624, F 756, F 762, and F 794.
[8] Vincent to Theo van Gogh and Johanna van Gogh-Bonger [640] (see note 3 above).
[9] Arikawa, in exh. cat. Tokyo 1985, p. 245.

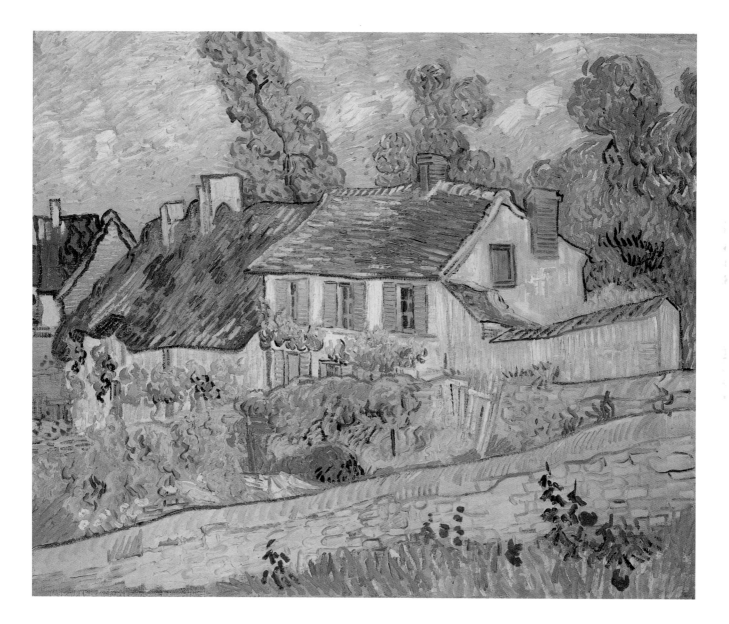

75

19 The Oise Valley near Auvers

May–June 1890
Pencil, chalk, brush with gouache, pen with brown ink,
47.3 x 62.9 cm (18 ⁵/₈ x 24 ³/₄ in.)
London, Tate
Bequeathed by C. Frank Stoop 1933
F 1639 JH 2023

In the first days after his arrival in Auvers, Van Gogh seems to have made a couple of drawings. In these large-format sheets he began by exploring the motifs that he found in this village along the Oise. *The Oise Valley near Auvers* probably belongs among these early drawings. It is not documented in Van Gogh's letters, but both the style and the motif fit well into this period.

The view looks over the river valley of the Oise from an elevated standpoint. In the foreground on the right one sees the embankment of the road, and from there the view sweeps over the landscape. In the middle ground fenced-in meadows and fields stretch to the riverbank, which is lined by poplars. A modern iron bridge passes over the river.[1] In the background, beyond the river, two factory buildings with tall smokestacks lie between the fields.[2] The landscape is thus characterized by the contrast of traditional agriculture and modern industry that Van Gogh had already taken as his theme for numerous paintings in Arles.[3]

The Oise Valley near Auvers is the only drawing in gouache on pink paper that Van Gogh made in Auvers. The technique and format reveal an ambition to create an autonomous work. Van Gogh worked in several steps, so that the different drawing materials often overlap and are sometimes hard to identify. He began the drawing by applying chalk. It is difficult to determine the extent to which he also used a soft pencil. By contrast, the cows,[4] poplars, and factory buildings, as well as the surrounding landscape, reveal preliminary drawing in a fine pen.

In a subsequent stage of work, the artist filled the flat areas with color. The brushstrokes are often loose and open, so that the pink ground of the paper contributes everywhere. The color scale is confined to green and blue hues; these are joined by the white of the cows and the much faded pink of the sky, which today looks almost white. The color scheme and the rhythm of the brush emphasize three things: the calmer, horizontal area of the fields in the foreground, the more agitated vertical, snaking lines of the trees, and finally the whirling strokes of the sky.

After color had been applied, Van Gogh added many contours in dark blue with the brush. This technique, which he had already employed frequently,[5] is particularly visible in the trees and in the landscape in the background. There he used the brush to apply over the flat areas of color a small-scale drawing of the factory buildings, the fields, and the trees. The poplars, the bridge, and the two bushes in the foreground were also partly reworked with blue-green brushstrokes. Consequently, in the large trees on the riverbank one finds both chalk and brush, both broad hatching with the brush and snaking blue brush drawing, superimposed to a many-layered—and yet translucent—structure that brings the complexity of this technique to a head.

If in the poplars and the fields the concern was above all with structures of color and graphics,[6] the drawing also emphasizes numerous narrative details. Van Gogh not only reproduces the topographical situation rather precisely but also places value on depicting the working people, the animals, the bridge, and the factory buildings. In doing so, he was picking up on his conception of landscape from the summer of 1888 in Arles, when he depicted the La Crau plain during the harvest. This approach can also be observed in other works from his first weeks in Auvers, for example, in the painting *Fields with Small Wagon* (F 760). Here he shows the view—still identifiable today—from the hill over the fields toward the Oise, and this painting too is laden with metaphor in the contrast of the horse-drawn cart and the railroad.

In subsequent weeks, however, Van Gogh moved away from this pictorial conception and picked up again an approach he had developed in Saint-Rémy with his paintings of uninhabited fields. Then he painted the plains of Auvers without any figures at all, choosing details that cannot be identified in terms of topography as they simply depict fields. The individual, the narrative, is increasingly replaced by the artist's hand itself. The fields thus become a comprehensive symbol.[7]

D. H.

[1] Pickvance, in exh. cat. New York 1986/87, p. 253, cat. no. 74. On this drawing, see also Pickvance, in exh. cat. Otterlo 1990, 319, cat. no. 245, and Pickvance, in exh. cat. Martigny 2000, cat. no. 86.
[2] It is also the site of the old village Méry-sur-Oise, which Van Gogh does not render here. I am grateful to Roland Dorn for pointing this out.
[3] See, for example, *Arles: View from the Wheat Fields* (F 545, here fig. 5 p. 22) and *The Land along the Banks of the Rhône, Seen from Montmajour* (F 1424).
[4] On this, see the pencil drawing of three cows, F 1632.
[5] See, for example, *View of Arles: The Iris* (F 409) or *View of the Asylum of Saint-Rémy* (F 734).
[6] Two sketches of the bank of the Oise (F 1627, F 1629) reveal a similar tree motif; here the concern is above all the contours and surfaces with internal structures.
[7] On the evolution of Van Gogh's pictorial language, see Dorn in this catalogue, pp. 23–28.

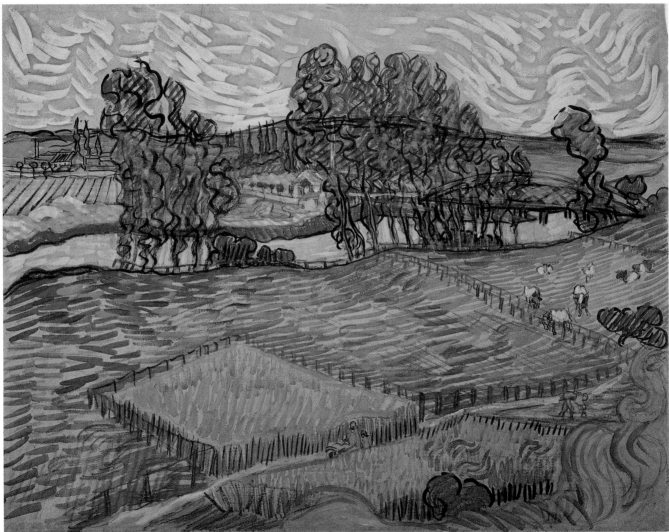

20 Harvest

June–July 1890
Black and blue chalk, 23.5 x 31 cm (9 1/4 x 12 3/16 in.)
Amsterdam, Van Gogh Museum (Vincent van Gogh Foundation)
d210 V/1962
F 1615r JH 2084

21 Two Women Harvesting Hay

June–July 1890
Black chalk, 23.5 x 30.5 cm (9 1/4 x 12 1/4 in.)
Amsterdam, Van Gogh Museum (Vincent van Gogh Foundation)
d214 V/1962
F 1626v JH 2088

In addition to the few large-format drawings such as cat. no. 19,[1] a sketchbook in octavo format[2] and nearly thirty study sheets in quarto format of various dimensions[3] have survived from Van Gogh's time in Auvers. While most of the large drawings are fully worked-out landscape compositions, the sketchbook reveals exclusively quickly sketched figures and animals. The study sheets in quarto format, by contrast, include both figures and landscapes, detail studies and complete compositions. As a whole, however, depictions of people play an important role here too.

The two present study sheets may serve to make this clear. The difference in the degree to which they are worked out reveals two different stages in the approach to a motif. *Two Women Harvesting Hay* is a fleeting sketch of two farm women in the field, working with rakes or pitchforks. With a few powerful strokes the artist renders the wheat in the foreground. Behind that one sees the women working, while the background is closed off by vertical strokes that pick up the motif from the foreground and intensify it. The haystack is character-ized only by its outline, so that the unworked sections of the paper are bright against the dark background. The foreground, the background, and the haystack are completely flat. It is only the overlapping that creates the illusion of space. The flatness and emphasis on contours recall the Cloisonnism in Gauguin's circle.

The sheet *Harvest*, by contrast, is a complete composition, in which the figures play a significant role. Two men work with scythes in a wheat field. They are defined entirely by their contours and simplified and deformed almost to the point of caricature. Behind them passes a heavily laden wagon. Van Gogh had depicted such a single-axle

wagon as early as his Arles painting *Harvest at La Crau* (F 412, fig. 1 p. 21). It is found in numerous works, including the painting *Fields with Small Wagon* (F 760) that Van Gogh painted in Auvers in June 1890. The landscape backdrop is difficult to make out. It cannot be said with certainty whether more fields stretch out beyond the road or whether the Oise is flowing there with houses and trees seen on the other bank in front of the distant chain of hills.

It is striking that Van Gogh gave so much space in his study sheets and sketchbook to depictions of figures. In his painting, he took the opposite path: there figures are increasingly less common, so that in the end only the pure, unpopulated landscapes are seen. During the same period in Auvers he painted a great number of portraits. The depiction of *active* figures *in* the landscape, however, seems to have been largely limited to study sheets. The only attempt in this direction was *Two Women before the Fields* (F 819). Much as in *Harvest,* there the landscape serves the figures as a stage. It is a work in oil on paper in which Van Gogh took the conception of figures with emphatic contours found in his study sheets and transferred it to a larger format and the color of oil studies.

D. H.

[1] Pickvance, in exh. cat. Otterlo 1990 and in exh. cat. New York 1986/87, p. 256, numbers ten large-format drawings in Auvers. Because we date F 1643 to after Saint-Rémy (see exh. cat. Bremen 2002/03, cat. no. 30) and do not place F 1641 in Auvers either, we recognize eight drawings.
[2] The dimensions are about 13 x 8 cm; about eighty-four of the sheets have been used; on this, see Van der Wolk 1987a, pp. 212–264.
[3] Many of them measure about 25 x 30 cm; some are as much as 40 cm wide.

22 *Epis de blé*
Ears of Wheat

June 1890
Oil on canvas, 64.5 x 48.5 cm (25 $^3/_8$ x 19 $^1/_{16}$ in.)
Amsterdam, Van Gogh Museum (Vincent van Gogh Foundation)
s88 V/1962
F 767 JH 2034

In April and May 1890 at Saint-Rémy Van Gogh depicted from close up an ordinary little section of meadow in two large paintings (see cat. no. 17). In the study *Ears of Wheat,* which he painted in mid-June in Auvers, he moved even closer to his motif.[1] The individual forms of the plants are clearly recognizable. The artist reproduces numerous yellow ears, including their entwined leaves; at upper left a blue cornflower is seen; at lower right, a bindweed and its flowers and dark green leaves. The upright ears and the dark green stalks emphasize the vertical and thus underscore the painting's upright format. The entwined leaves of the plants undercut this strict rhythm, resulting in a "weave" with an ornamental feel that emphasizes the painting's flatness. The impression of depth that was so characteristic of *Meadow in the Garden of Saint-Paul Hospital* (cat. no. 17) thus disappears almost entirely. Only the somewhat small and summarily rendered ears at the upper left edge point to a greater spatial distance.

The painting feels like a small, arbitrary detail from an immeasurably large field. It reveals an ornamental allover painting that dispenses with any particular compositional accent. Van Gogh himself saw it as a study with a very definite function. He wrote to Gauguin: "Look, here's an idea which may suit you, I am trying to do some studies of wheat like this, but I cannot draw it—nothing but ears of wheat with green-blue stalks, long leaves like ribbons of green shot with pink, ears that are just turning yellow, edged with the pale pink of the dusty bloom—a pink bindweed at the bottom twisted around a stem. After this I would like to paint some portraits against a very vivid yet tranquil background. There are the greens of a different quality, but of the same value, so as to form a whole of green tones, which by its vibration will make you think of the gentle rustle of the ears swaying in the breeze: it is not at all easy as a color scheme."[2]

He included two small sketches with the letter: one shows a single ear of wheat from close up; the other reproduces—greatly simplified—the overall structure of this painting. With these *two* sketches of *one* oil study the artist points to the tension that results in this work between the detailed reproduction of the plants and the overall flat, ornamental impression it produces.[3] A comparable phenomenon is found in three studies of roses and poppies with butterflies that Van Gogh probably painted in May or June 1889 in Saint-Rémy.[4] In these flat vegetal studies one can see the influence of Japanese graphic works that was so strong in Arles and that hardly plays a role in Van Gogh's other works from Auvers.[5] Here the painter increasingly chose freer brushwork for motifs seen close up, which tended to emphasize the painterly structures of strokes, squiggles, and dots more than the closed forms of the objects.[6]

Van Gogh did indeed carry out his plan to use *Ears of Wheat* as a background for portraits. In late June or early July 1890 he painted a half-length figure of a farm woman in a straw hat sitting against this background (F 774).[7] A little later he did a variant of this portrait with the same woman, this time standing in a white dress against a similar background (F 788). In both paintings the ears of wheat are highly simplified into a decorative structure that is, moreover, interspersed with red dots: the poppies. In the painting of the standing woman there are also hints of the bindweeds with their heart-shaped leaves and pink flowers that are already found in the study *Ears of Wheat.*

D. H.

[1] On this painting, see above all Richard Kendall, in exh. cat. Washington/Los Angeles 1998/99, cat. no. 68, p. 137.
[2] Vincent van Gogh to Paul Gauguin, about June 16, 1890 [643].
[3] For illustrations of the two sketches, see Johanna van Gogh-Bonger, ed., *Verzamelde Brieven van Vincent van Gogh* (Amsterdam and Antwerp, 1953) vol. 3, p. 528, and Mothe 1987, p. 79.
[4] F 597, F 749, and F 748.
[5] See Kodera, in coll. cat. Amsterdam 1991a, pp. 40, 41.
[6] See, for example, the watercolors F 1526 and F 1527. There are numerous other examples.
[7] Vincent to Theo van Gogh, about July 2, 1890 [646]; Van Gogh sketched the portrait in this letter.

23 *Champ vert de froment*
Green Wheat Field

June 1890
Oil on canvas, 48.5 x 62.8 cm (19 1/$_8$ x 24 1/$_4$ in.)
Washington, D.C., The Phillips Collection
Acquired 1952, 0797
F 804 JH 2018

Around June 12, 1890, Van Gogh described in a letter to his sister, Wilhelmina, three landscapes that he had just painted in Auvers. They were *Fields with Small Wagon* (F 760), *Vineyards with View of Auvers* (F 762), "[A]nd another [landscape] with nothing but a green field of wheat, stretching away to a white country house, surrounded by a white wall with a single tree."[1]

The viewer is immediately confronted with the green field of wheat, which takes up more than three quarters of the painting. With no frame on the sides or salient motif in the foreground, the selection of the detail in the painting seems almost arbitrary: the field extends infinitely beyond the limits of the painting. Only at front right does one see an arabesque form in light green shades that is difficult to interpret. Perhaps tufts of grass are thrusting over from the edge of the field. Cramped into the upper edge of the painting stands a white wall, beyond which a house and a smaller building are visible, with summarily sketched trees as a backdrop. Only a narrow strip of sky can be seen.

Van Gogh had already developed very similar compositions in the summer of 1888 in Arles, in which wheat fields or plowed fields dominate the canvas, while distant houses or the backdrop of the town and a narrow strip of sky are crowded into the upper edge of the painting.[2] A decisive factor in the pictorial effect was his overcoming of the giant plane of the field, which is articulated by the rhythm of the brushstrokes and the use of color. Van Gogh had been aware of this problem since the summer of 1888, when he painted two seascapes in Saintes-Maries-de-la-Mer in which depicting the water masses presented him with a similar task.[3]

In *Green Wheat Field* the artist's handling of this task is complete. The study seems to have been worked through quickly. It looks very sketchlike, and in several places the primed canvas remains visible.[4] The field is rendered in a graduated scale of white, yellow, and green hues. In the foreground the brushstrokes are longer and more curved, and several bowing ears are even characterized by black or dark green contours. The white accents are also concentrated in this area. Further back the brushstrokes are shorter and more oblique, until finally in the far distance longer horizontal strokes sum up the view of the field. In this way Van Gogh used the varied rhythm and the length of his brushstrokes, as well as a color scale that is reduced stepwise as one moves from front to back, to create an illusion of immense depth. The overall artistic structure is more important here than the depiction of the individual plants.[5]

D. H.

[1] Vincent to Wilhelmina van Gogh, about June 13, 1890 [W 23].
[2] See, for example, *Sunset: Wheat Fields near Arles* (F 465, here fig. 3 p. 21) or *The Sower* (F 494).
[3] See *The Departure of the Fisherman* (F 417) and *The Return of the Fisherman* (F 415); on this, see Dorn in the present catalogue, p. 25.
[4] On this, see also Pickvance in exh. cat. New York 1986, p. 237, cat. no. 65.
[5] See, by way of comparison, F 767, here cat. no. 22.

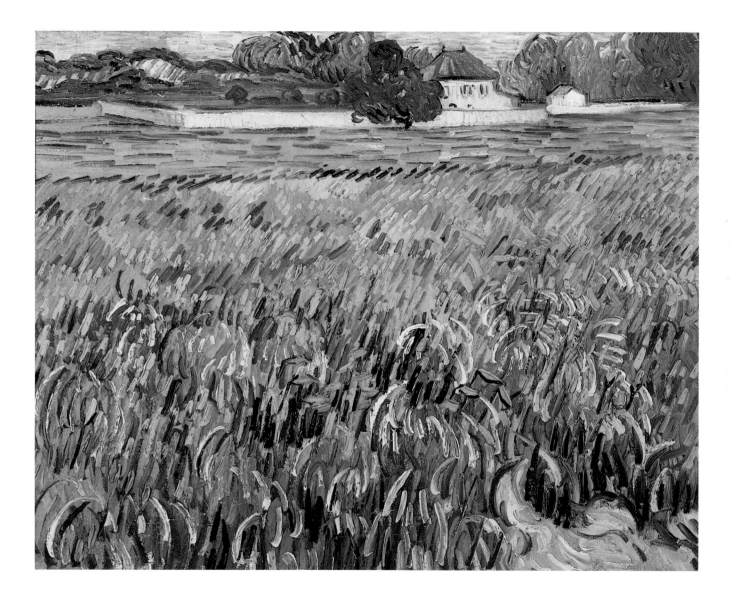

24 *Champs, après la pluie*
Wheat Fields at Auvers under Clouded Sky

July 1890
Oil on canvas, 73 x 92.1 cm (28 ³/₄ x 36 ¹/₄ in.)
Pittsburgh, Carnegie Museum of Art
Acquired through the generosity of the Sarah Mellon Scaife Family,
1968, 68.18
F 781 JH 2102

The wheat fields near Auvers held Van Gogh's attention during June and July 1890. Altogether, he painted more than a dozen canvases devoted to this motif. In *Wheat Fields at Auvers under Clouded Sky* he depicts almost exactly the same scene as in *Wheat Fields near Auvers* (F 775, fig. 13 p. 32). However, changes in composition, coloring, artistic style, and size produced a painting of an entirely different character.

The view gazes across the fields from an elevated standpoint. Blades of grass and flowers are seen from very close up in the foreground. The terrain slopes downward, opening to a view of the fields on the gently rising plain some distance beyond. The dark contours of the fields exert a pull into the depth of the scene. At first, they appear to move toward a vanishing point in the right-hand half of the picture, but then they shift at a sharp angle and draw the eye to the hilltop on the horizon to the left. Fields, paths, and rows of trees are clearly distinguishable even in the distance.

The compact brushstrokes underscore the pull into the distance. While short, parallel hatchings dominate in the foreground, long, extended lines enhance the effect of perspective in the middle ground. The zigzag shift becomes a prominent motif. Behind this point, the brushstrokes take on a more horizontal orientation before giving way to the sky. The broad, rounded brushstrokes of the white clouds and the pale blue remnants of the storm clouds stand in contrast to the almost geometric pattern of the fields. The clouds are modeled directly in paint, while the artist used contour lines in the fields. These allow the gaze to glide quickly into the distance and come to rest on the spectacle in the sky.

In his last letter to Theo, Van Gogh sent along "...sketches of two size 30 canvases representing vast fields of wheat after the rain."[1] One of the sketches shows this painting. The "after-the-rain" mood is reinforced by the coloring. The dominant tones are greens and blues, which evoke a sense of cool moisture spreading over the scene. Only the yellow fields contain isolated warm accents. Purple and brown appear in the foreground, while the white of a few blossoms in the foreground forges a link to the white clouds in the sky. Strong complementary contrasts are missing in this largely tonal composition.

The accents are different in the earlier double-square painting entitled *Wheat Fields near Auvers* (fig. 13). The true focus here does not lie in the distance or in the sky, but rather in the foreground. The differences in the format and the height of the sky in these two paintings are even more marked. The extreme horizontal format of *Wheat Fields near Auvers* emphasizes the endless expanse of the landscape primarily through its breadth, while the familiar size 30 canvas that Van Gogh used for this painting tends to draw the gaze into the depth of the scene. The different effects are similar to those achieved in photography using a wide-angle or a telephoto lens, respectively. The high sky and the billowing clouds pull the gaze into the distance in *Wheat Fields at Auvers under Clouded Sky,* while the narrow, monochrome strip of sky in the other painting virtually turns the eye back to the foreground.

Wheat Fields at Auvers under Clouded Sky is one of the last pictures Van Gogh painted.[2] He mentions it in his last letter to Theo on July 23,[3] but he had already told his sister and his mother how impressed he was with the plain near Auvers in a letter written on July 10/11: "I myself am quite absorbed in the immense plain with wheat fields against the hills, boundless as a sea, delicate yellow, delicate soft green, the delicate violet of a dug-up and weeded piece of soil, checkered at regular inervals with the green of flowering potato plants, everything under a sky of delicate blue, white, pink, violet tones. I am in a mood of almost too much calmness, in the mood to paint this."[4]

This painting places Van Gogh within the tradition of such painters as his seventeenth-century Dutch predecessors Jacob van Ruisdael and Philips Koninck and the French artists Georges Michel and Charles-François Daubigny.

D. H.

[1] Vincent to Theo van Gogh, July 23, 1890 [651]; the sketches are JH 2100, JH 2103.
[2] On this painting see exh. cat. Saint Louis 1989, cat. no. 39; Pickvance, in exh. cat. New York 1984, cat. no. 73.
[3] Vincent to Theo van Gogh, July 23, 1890 [651].
[4] Vincent to Wilhelmina van Gogh and his mother, about July 10/11, 1890 [650].

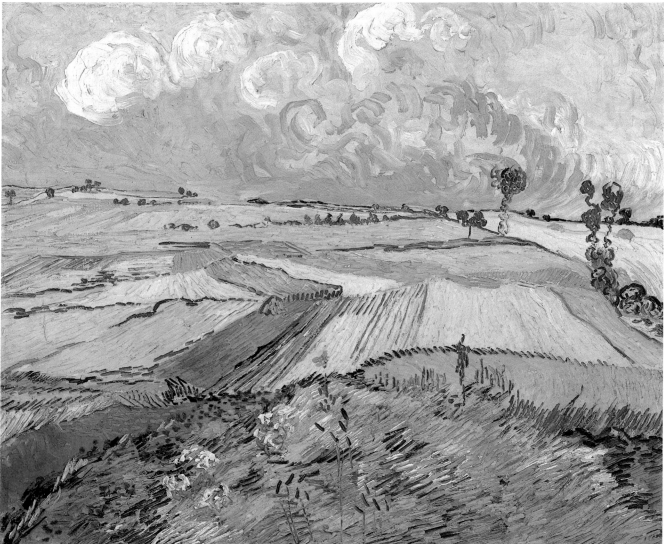

85

25 The Fields

July 1890
Oil on canvas, 50 x 65 cm (19 $^{11}/_{16}$ x 25 $^{9}/_{16}$ in.)
Private Collection
F 761 JH 2120

This painted study is one of several works devoted to the view of the plain near Auvers.[1] In this case, Van Gogh did not choose an elevated position, as he had in *Wheat Fields at Auvers under Clouded Sky* (cat. no. 24) and *Wheat Fields near Auvers* (F 775, fig. 13 p. 32), but instead moved closer to the field. Large stalks of wheat—added during a later painting session—rise high in the foreground, but these graphic elements are largely overshadowed by the undulating field of grain that stretches out before the viewer. Rendered in colors ranging from yellow to ochre, the field is sprinkled with tiny red dabs, representing poppies, and full of green stalks that reflect the motion of the grain. The waving lines show the effect of the wind, which bends the wheat to the right.

The wheat field occupies nearly half of the canvas. The viewer's gaze is then shifted quite abruptly to the hill in the far distance. The trees and fields visible there are very small and thus emphasize the tremendous distance between the foreground and the background. This distance is shorter in the right-hand half of the painting, where a long stack of straw obscures the view of the horizon. Above the whole scene is the radiant blue sky, in which the soft brushstrokes mirror the rounded forms of the stack of straw and the undulating pattern of the grain.

The composition makes do with virtually no vanishing lines. Depth is apparent only in the fields on the rising terrain in the distance. The orientation here is horizontal, and the color scheme reinforces this effect. Thus yellow, interspersed with green accents, dominates the lower half of the canvas, while various gray tones prevail in the middle section, and the deep blue of the sky forms a powerful contrast with the yellow field in the foreground. The blue of the sky is so luminous that it seems to "reflect" itself in the field. The bluish areas in the field, on the stack of straw, and on another field in the background establish a visual link between the earth and the sky.

The painting, which is not mentioned in Van Gogh's correspondence, was probably done in July 1890. He is known to have worked intensively on motifs on the same plain near Auvers during those weeks. This study cannot be regarded as a preliminary work for a specific painting, however. Van Gogh was very concerned with exploring the various effects of different perspectives in images of fields at that time. Here on the plain near Auvers, he was once again concerned with the contrast between extreme close-up and vast distance, a theme he had addressed in Arles in the harvest series and then with even greater frequency in the garden pictures in Saint-Rémy.

D. H.

[1] For a discussion of the painting, see Dorn, in exh. cat. Essen/Amsterdam 1990/91, cat. no. 61. See also exh. cat. Lausanne 1984, cat. no. 113, and exh. cat. London 1995, cat no. 75.

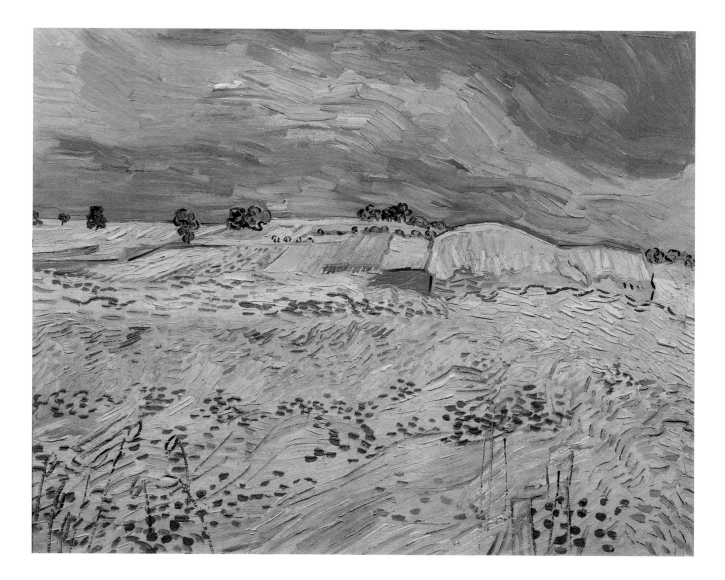

26 Wheat Fields with Reaper, Auvers

July 1890
Oil on canvas, 73.6 x 93 cm (29 x 36 ⁵/₈ in.)
Toledo, Toledo Museum of Art
Purchased with funds from the Libbey Endowment,
Gift of Edward Drummond Libbey, 1935.4
F 559 JH 1479

Beneath a turquoise sky lies a bright yellow field of grain where a reaper is at work. A large number of stacked sheaves form a passage that extends diagonally into the depth of the scene. Neighboring green, yellow, and white fields stretch into the distance, where the terrain rises and a small town with a church spire and a chimney can be seen. Subject matter and coloration call to mind the harvest series from Arles done during the summer of 1888 (compare cat. nos. 10–12 and figs. 1–6 pp. 21 and 22). These similarities explain why the painting has been dated to the Arles period until recently.[1]

Stylistically speaking the painting does not appear to belong to this period, however. The rough, open painting style of the harvest series of 1888 has little in common with the flowing impasto brushwork in this painting, and the short, abrupt brushstrokes of the Arles studies bear little resemblance to the softer lines seen, grouped in whorls and—as in the shrubbery in the foreground—forming ringlets and circular shapes. In addition, the composition of the Arles works is concentrated primarily on flat, two-dimensional foregrounds, while the middle ground, which opens a view into the depth of the scene, is dominant in this painting.

Aspects of style and composition point therefore to an origin in the summer of 1890, and the topography also supports attribution to the period of Van Gogh's stay in Auvers-sur-Oise.[2] The small town in the painting can hardly be intended to represent the city of Arles. It is more suggestive of Auvers, and the long chain of hills on the left calls to mind the landscape along the Oise near that town. The exact location of the scene is, however, impossible to determine.

The painting is not mentioned in the letters,[3] and it remains strangely isolated within the context of Van Gogh's work in Auvers. Figures do not appear in most of the other pictures of fields done during this period, and this particular topography is depicted in no other work. Yet a review of Van Gogh's paintings and drawings of the preceding three years shows that this painting has its logical place in the

sequence. Like the sower, the reaper was a recurring leitmotif; thus the summer of 1890 was the third in succession in which Van Gogh took up this theme. He employed the reaper as an incidental figure in Arles (see figs. 5 and 6 p. 22), and we encounter the figure in the work of the same title done in Saint-Rémy the following year (fig. 9 p. 27). In his letters from that period, Van Gogh interpreted the reaper as a symbol of death, to which he opposed the fruit-bringing *Sower* (fig. 7 p. 24) that he had previously painted in Arles as a paradigmatic contrast.[4]

Thus Van Gogh employed the motif of the reaper with much the same regularity as his field scenes. Yet while his paintings and drawings from Arles are populated with numerous farm workers, and while he described the various farming activities he observed over the course of his year in Saint-Rémy, the reaper is an exception among the works completed in Auvers. It appears only once more during the Auvers period, in the painting entitled *Landscape with Carriage and Train in the Background* (F 760, now in the State Pushkin Museum of Fine Arts, Moscow). This may be a consequence of the season, however. Farmers have little to do in the fields when crops are ripening, and the harvest did not begin in Auvers until mid-July. Above all, however, Van Gogh in Auvers increasingly dispensed with these metaphoric figures, favoring instead the comprehensive expression of pure landscape.

D. H.

[1] Compare De la Faille 1970 and Hulsker 1996, for example.
[2] Arguments for the new dating were first published by Marc S. Gerstein in exh. cat. Saint Louis 1989, cat. no. 40. See also Gerstein in coll. cat. Toledo 1995, pp. 142–143.
[3] An alleged second version of this painting (F 560) has since been exposed as a forgery. Compare Dorn and Feilchenfeldt 1993, p. 285.
[4] See Vincent to Theo van Gogh, about September 2–6, 1889 [604].

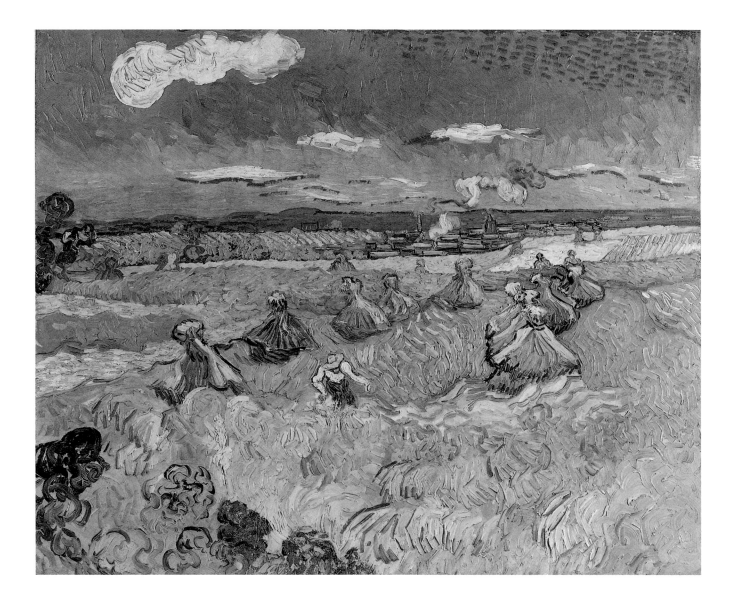

27 Wheat Field with Cornflowers

July 1890
Oil on canvas, 60.3 x 81.3 cm (23 ³/₄ x 32 in.)
Riehen/Basel, Fondation Beyeler
Inv. 97.1
F 808 JH 2118

Van Gogh painted the view across the fields on the wide plain at Auvers again and again. In this study, he depicted a wheat field from close up.[1] A confused jumble of brushstrokes confronts the viewer. Longer yellow and yellowish-green strokes represent the stalks; short, comma-shaped strokes in green, yellow, and orange, most of which appear in discrete groups, denote the ears of grain. Thus, within the confusion, the viewer senses a structure that calls to mind motion in a field of grain. The field is also speckled with groups of deep blue spots—the cornflowers. The entire field emphasizes the foreground, as even the more distant ears of grain are painted with brushstrokes almost as large as those toward the front.

Within the context of the painting, this animated fabric of brushstrokes is recognizable as a wheat field. The shapes in the left-hand corner of the canvas are more difficult to interpret, however. The specific way in which the green strokes are grouped suggests clumps of grass growing alongside a field, and their presence gives this area a strongly two-dimensional appearance, yet certain aspects lead to the conclusion that the wedge represents a path that leads into the depths toward the left. The diagonal itself seems to imply a vanishing point. The green strokes grow somewhat smaller toward the upper left, and their arrangement takes on a more summary quality. A small area of hatched lines extends in a wedge-shaped pattern from the lower edge of the canvas along the grass into the upper section of the picture, suggesting a narrowing of perspective. This element may represent a small embankment or a carriage track. The brown in the foreground also supports a reading as a path through the fields.

The wheat field and the path occupy two thirds of the canvas. They appear as a block, much like a wall that obscures the view into the distance. Their two-dimensional quality is underscored by the presence of the brushwork and the almost complete absence of indications of spatial depth. The view opens above the field, where one sees the blue strip of distant hills that echoes the color tones of the cornflowers. Above it is the light-blue sky with white clouds. The smooth, flat application of color on the mountains, with their black contours, contrasts with the animated brushwork of the field and emphasizes the distance between the foreground and the background, which collide abruptly with one another in this painting.

Showing a close-up view of the field, this work is a pendant to the expansive views of the plain near Auvers—works such as *Wheat Fields near Auvers* (F 775, fig. 13 p. 32) and *Wheat Fields at Auvers under Clouded Sky* (cat. no. 24). Aspects of distance and proximity, expansive view and close-up confrontation, were of particular concern to Van Gogh in the famous painting entitled *Wheat Field with Crows* (F 779, fig. 15 p. 32). The left-hand portion of that painting calls this work to mind, and it may be that Van Gogh used this oil study in preparation for the larger work. The use of perspective in depicting the two other paths in *Wheat Field with Crows* makes it easier to read its representational meaning and spatial configuration; the immediate, surface-oriented proximity of the fields stands in strong contrast to the paths, which suggest spatial depth. In this work, the view into the distance beyond the fields is blocked entirely by yellow ears of grain. There is nothing above them but the dark blue sky and the crows.

D. H.

[1] Coll. cat. Basel 1997, no. 10.

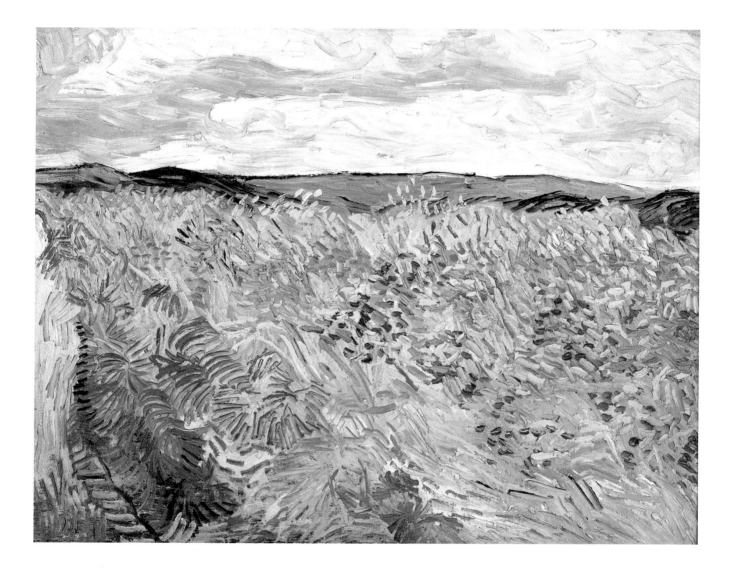

Map

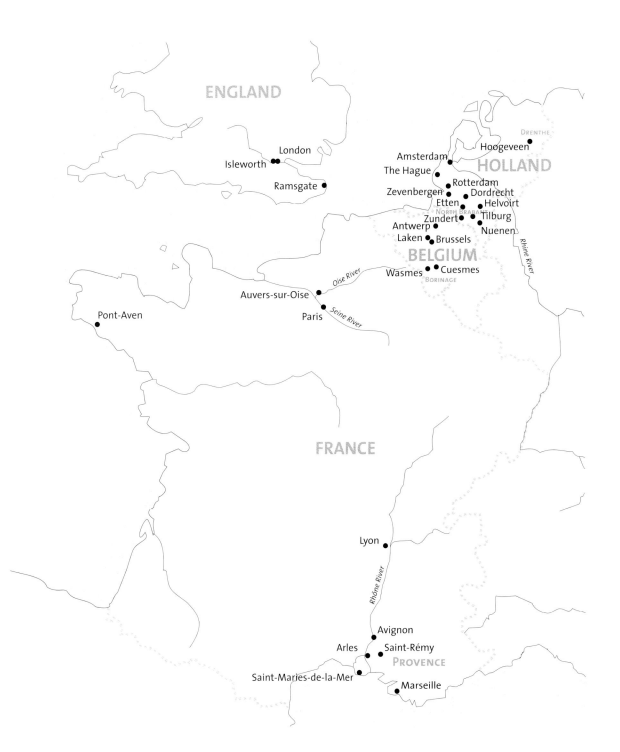

ENGLAND

London
Isleworth
Ramsgate

Hoogeveen
DRENTHE
HOLLAND

Amsterdam
The Hague
Rotterdam
Zevenbergen
Dordrecht
Etten
Helvoirt
NORTH BRABANT
Zundert
Tilburg
Antwerp
Nuenen
Laken
Brussels
BELGIUM
Wasmes
Cuesmes
BORINAGE
Oise River
Rhine River
Auvers-sur-Oise
Paris
Seine River
Pont-Aven

FRANCE

Lyon

Rhône River

Avignon
Arles
Saint-Rémy
PROVENCE
Saint-Maries-de-la-Mer
Marseille

93

Bibliography

Note: The published literature on Vincent van Gogh is enormous. The books and articles listed below provide full citations for the abbreviations used in this catalogue.

Catalogues raisonnés and editions of Vincent van Gogh's Letters

The Complete Letters of Vincent van Gogh with Reproductions of all the Drawings in the Correspondence, 3 vols. (Greenwich, Conn., New York Graphic Society n.d. [1958]).

Faille, Jacob Baart de la, *L'Oeuvre de Vincent van Gogh. Catalogue raisonné*, 4 vols. (Paris/Brussels 1928).

Faille, Jacob Baart de la, *The Works of Vincent van Gogh. His Paintings and Drawings*, rev, ed. A. M. Hammacher et al. (Amsterdam 1970).

Hulsker, Jan, "Vincent's Stay in the Hospitals at Arles and St. Rémy. Unpublished Letters from Reverend Mr. Salles and Doctor Peyron to Theo van Gogh," *Bulletin of the Rijksmuseum Vincent van Gogh* vol. 1.2 (1971) pp. 24–44.

Hulsker, Jan, *The Complete Van Gogh. Paintings, Drawings, Sketches* (New York 1977).

Hulsker, Jan, *The New Complete Van Gogh. Paintings, Drawings, Sketches. Revised and enlarged edition of the Catalogue Raisonné of the Works of Vincent van Gogh* (Amsterdam/Philadelphia 1996).

Scherjon, W., and Jos de Gruyter, *Vincent van Gogh's Great Period: Arles, St. Rémy, and Auvers sur Oise (Complete Catalogue)* (Amsterdam 1937).

Verzamelde Brieven van Vincent van Gogh, ed. Johanna van Gogh-Bonger, 3 vols. (Amsterdam/Antwerp 1952/53).

Vincent van Gogh – Sämtliche Briefe, ed. Fritz Erpel, 6 vols. (Berlin 1965).

Books and Essays

Arnold, Matthias, *Vincent van Gogh. Werk und Wirkung* (Munich 1995).

Arnold, Matthias, *Van Gogh und seine Vorbilder: Eine künstlerische Selbstfindung* (Munich 1997).

Billeter, Felix and Andrea Pophanken (eds.), *Die Moderne und ihre Sammler: Französische Kunst in deutschem Privatbesitz vom Kaiserreich zur Weimarer Republik* (Berlin 2001).

Chetham, Charles, *The Role of Vincent van Gogh's Copies in the Development of his Art* (Ph.D. diss. Harvard University; Cambridge, Mass. 1960; New York 1976).

Dorn, Roland, *Décoration. Vin00nt van Goghs Werkreihe für das Gelbe Haus in Arles* (Hildesheim 1990).

Dorn, Roland, "Vincent van Gogh," in exh. cat. Essen/Amsterdam 1990/91, pp. 31–38.

Dorn, Roland, catalogue entries on Vincent van Gogh, in exh. cat. Essen/Amsterdam 1990/91, pp. 67–187.

Dorn, Roland, "Die künstlerische Auseinandersetzung mit Vincent van Gogh," in exh. cat. Essen/Amsterdam 1990/91, pp. 189–203.

Dorn, Roland, "'The thoughts of youth are long, long thoughts'—Van Goghs Frühwerk," in exh. cat. Vienna 1996, pp. 31–49.

Dorn, Roland, "Vincent van Gogh (1853–1890)," in *Van Gogh und die Haager Schule*, exh. cat. Vienna 1996, pp. 53–235.

Dorn, Roland, "'Refiler à Saintes-Maries?' Pickvance and Hulsker revisited," *The Van Gogh Museum Journal*, vol. 3 (1997/98) pp. 14–25.

Dorn, Roland, "Vincent van Gogh, Soir d'été," in *Van Gogh, Van Doesburg, De Chirico, Picasso, Guston, Weiner, Mangold, Richter, Texte zu Werken im Kunstmuseum Winterthur*, ed. Dieter Schwarz (Düsseldorf 2000) pp. 11–41.

Dorn, Roland, and Walter Feilchenfeldt, "Genuine or Fake? On the History and Problems of Van Gogh Connoisseurship," in *The Mythology of Vincent van Gogh*, ed. Tsukasa Kodera (Tokyo 1993) pp. 263–307.

Feilchenfeldt, Walter, *Vincent van Gogh & Paul Cassirer, Berlin. The Reception of Van Gogh in Germany from 1901–1914* (Zwolle 1988).

Feilchenfeldt, Walter, "Vincent van Gogh – seine Sammler – seine Händler," in *Vincent van Gogh und die Moderne*, in exh. cat. Essen/Amsterdam 1990/91, pp. 39–46.

Gachet, Paul, *Les 70 jours de Van Gogh à Auvers* (n.p. 1994).

Hartlaub, Gustav Friedrich, "Eine Zeichnung Van Goghs zu seinem in der Kunsthalle befindlichen Gemälde," in *Jahrbuch der bremischen Sammlungen* 4 (1911) pp. 76–78.

Hendriks, Ella, and Louis van Tilborgh, "Van Gogh's 'Garden of the Asylum,' genuine or fake?," in *The Burlington Magazine* 143, no. 1176 (2001) pp. 145–156.

Homburg, Cornelia, *The Copy Turns Original: Vincent van Gogh and a New Approach to Traditional Art Practice* (Amsterdam/Philadelphia 1996).

Kodera, Tsukasa, "Van Gogh's Utopian Japonisme," in *Catalogue of the Van Gogh Museum's Collection of Japanese Prints*, coll. cat. Amsterdam 1991a, pp. 11–45.

Lenz, Christian, "Julius Meier-Graefe in seinem Verhältnis zu Vincent van Gogh," in *Vincent van Gogh und die Moderne*, exh. cat. Essen/Amsterdam 1990/91, pp. 47–59.

Machotka, Pavel, *Paul Cézanne: Landscape into Art* (New Haven 1996).

Meier-Graefe, Julius, *Entwicklungsgeschichte der modernen Kunst* (Stuttgart 1904).

Mothe, Alain, *Vincent van Gogh à Auvers-sur-Oise* (Paris 1987).

Noll, Thomas, "Zur Bedeutung des Raumes in der Kunst von Vincent van Gogh," in *Wallraf-Richartz-Jahrbuch* 44 (1993) pp. 233–264.

Noll, Thomas, *"Der große Sämann": Zur Sinnbildlichkeit in der Kunst von Vincent van Gogh* (Worms 1994).

Pickvance, Ronald, *Van Gogh in Arles*, exh. cat. New York 1984.

Pickvance, Ronald, *Van Gogh in Saint-Rémy and Auvers*, exh. cat. New York 1986/87.

Pickvance, Ronald, "Saint-Rémy-de-Provence," in *Vincent van Gogh Drawings*, exh. cat. Otterlo 1990, pp. 283–288.

Pickvance, Ronald, *Van Gogh*, exh. cat. Martigny 2000.

Rewald, John, *Post-Impressionism: From Van Gogh to Gauguin* (3rd ed., New York 1978).

Rewald, John, Walter Feilchenfeldt, and Jayne Warman, *The Paintings of Paul Cézanne: A Catalogue Raisonné* (New York 1996).

Roskill, Marc W., "Van Gogh's 'Blue Cart' and His Creative Process," in *Oud Holland*, vol. 81 (1966) pp. 3–19.

Roskill, Marc W., "Van Gogh's exchanges of work with Émile Bernard in 1888," in *Oud Holland*, vol. 86 (1971) pp. 142–179.

Silverman, Debora, *Van Gogh and Gauguin: The Search for a Sacred Art* (New York 2000).

Stiles Wylie, Anne, "An Investigation of the Vocabulary of Line in Vincent van Gogh's Expression of Space," *Oud Holland*, vol. 85 (1970) pp. 210–235.

Sund, Judy, "Family to Feast: Portrait Making at St.-Rémy and Auvers," in exh. cat. Detroit/Philadelphia/Boston 2000, pp. 183–227.

Van der Wolk, Johannes, *The Seven Sketchbooks of Vincent van Gogh. A Facsimile Edition* (London 1987a).

Van der Wolk, Johannes, "Seven Sketchbooks," in Evert van Uitert and Michael Hoyle, *The Rijksmuseum Vincent van Gogh* (Amsterdam 1987b) pp. 45–50.

Van Tilborgh, Louis, "Traductions en couleur, les copies de Van Gogh d'après Millet," in exh. cat. Paris 1998/99, pp. 120–158.

Van Tilborgh, Louis, and Sjraar van Heugten, "Semeurs," in exh. cat. Paris 1998/99, pp. 90–105.

Van Uitert, Evert, and Michael Hoyle, *The Rijksmuseum Vincent van Gogh* (Amsterdam 1987).

Wadley, Nicholas, *Impressionist and Post-Impressionist Drawing* (London 1991).

Zemel, Carol, *Van Gogh's Progress. Utopia, Modernity, and Late Nineteenth-Century Art* (Berkeley/Los Angeles/London 1997).

Exhibition Catalogues

Amsterdam 1988/89
Van Gogh & Millet, exh. cat., Van Gogh Museum Amsterdam.

Amsterdam 1990
Vincent van Gogh Paintings, exh. cat., Van Gogh Museum Amsterdam.

Amsterdam 1999
Theo van Gogh, 1857–1891: Art Dealer, Collector, and Brother of Vincent, exh. cat., Chris Stolwijk and Richard Thomson, Van Gogh Museum Amsterdam.

Berlin/Munich 1996/97
Manet bis Van Gogh. Hugo von Tschudi und der Kampf um die Moderne, exh. cat., Nationalgalerie Berlin/Neue Pinakothek Munich.

Bremen 2002/03
Van Gogh: Fields—The Field with Poppies and the Artists' Dispute, ed. Wulf Herzogenrath and Dorothee Hansen, exh. cat., Kunsthalle Bremen.

Chicago/Amsterdam 2001/02
Van Gogh and Gauguin: The Studio of the South, exh. cat., The Art Institute of Chicago/Van Gogh Museum Amsterdam.

Copenhagen 1984/85
Gauguin and van Gogh in Copenhagen in 1893, exh. cat. Ordrupgaardsamlingen.

Detroit/Philadelphia/Boston 2000
Van Gogh: The Portraits, exh. cat., Detroit Institute of Art/Philadelphia Museum of Art/Museum of Fine Arts, Boston.

Essen/Amsterdam 1990/91
Vincent van Gogh und die Moderne, exh. cat., Museum Folkwang Essen/Van Gogh Museum Amsterdam.

Lausanne 1984
L'Impressionisme dans les collections romandes, exh. cat., Fondation de l'Hermitage.

London 1995
From Manet to Gauguin: Masterworks from Swiss Private Collections, exh. cat., Royal Academy.

Martigny 2000
Van Gogh, exh. cat., Fondation Pierre Gianadda.

New York 1984
Van Gogh in Arles, exh. cat., The Metropolitan Museum of Art.

New York 1986/87
Van Gogh in Saint-Rémy and Auvers, exh. cat., The Metropolitan Museum of Art.

Ontario 1981
Vincent van Gogh and the Birth of Cloisonnism: An overview; Paul Gauguin, Louis Anquetin, Émile Bernard, Henri de Toulouse-Lautrec, Jacob Meyer de Haan, Charles Laval, Maurice Denis, Paul Sérusier, exh. cat., Art Gallery of Ontario.

Ottawa 1999
Van Gogh's Irises, Masterpieces in Focus, exh. cat., National Gallery of Canada.

Ottawa/Boston/Richmond/Houston 2000/01
Monet, Renoir and the Impressionist Landscape, exh. cat., National Gallery of Canada, Ottawa / Museum of Fine Arts, Boston/Virginia Museum of Fine Arts, Richmond/Museum of Fine Arts, Houston.

Otterlo 1990
Vincent van Gogh Drawings, exh. cat., Kröller-Müller Museum.

Paris 1986
Van Gogh à Paris, exh. cat., Musée d'Orsay.

Paris 1998/99
Millet & Van Gogh, exh. cat., Musée d'Orsay.

Rome 1988
Vincent van Gogh, exh. cat., Galleria Nazionale d'Arte Moderna.

Saint Louis 1989
Impressionism: Selections from Five American Museums, exh. cat., Saint Louis Art Museum, Carnegie Museum of Art, Minneapolis Institute of Arts, Nelson-Atkins Museum Kansas City, Toledo Museum of Art (St. Louis 1989).

Saint Louis 2001
Vincent van Gogh and the Painters of the Petit Boulevard, exh. cat., The Saint Louis Art Museum.

Tokyo 1985
Vincent Van Gogh, exh. cat., The National Museum of Western Art.

Vienna 1996
Van Gogh und die Haager Schule, exh. cat., Bank Austria Kunstforum.

Washington, D.C./Los Angeles 1998/99
Van Gogh's Van Goghs: Masterpieces from the Van Gogh Museum Amsterdam, exh. cat., National Gallery of Art/Los Angeles County Museum of Art.

Yokohama/Nagoya 1995/96
Vincent van Gogh Collection from the Kröller-Müller Museum, exh. cat., Yokohama Museum of Art/Nagoya City Art Museum.

Collection Catalogues

Amsterdam 1991a
Catalogue of the Van Gogh Museum's Collection of Japanese Prints, ed. Charlotte van Rappard-Boon, Willem van Gulik, and Keiko van Bremen-Ito.

Amsterdam 1991b
Van Gogh Museum – Aanwinsten/Acquisitions 1986–1991.

Amsterdam 1996
Vincent van Gogh, Drawings. Volume I: *The Early Years 1880–1883, Van Gogh Museum,* ed. Sjraar van Heugten.

Amsterdam 1997
Vincent van Gogh, Drawings. Volume II: *Nuenen 1883–1885, Van Gogh Museum,* ed. Sjraar van Heugten.

Amsterdam 1999
Vincent van Gogh, Paintings. Volume I: *Dutch Period 1881–1885, Van Gogh Museum,* ed. Louis van Tilborgh and Marije Vellekoop.

Basel 1997
Fondation Beyeler, anlässlich der Eröffnung der Fondation Beyeler, Riehen/Basel, am 21.10.1997.

Otterlo 1980
A detailed catalogue of the paintings and drawings by Vincent van Gogh in the collection of the Kröller-Müller National Museum.

New York/Guggenheim 1992
Guggenheim Museum Thannhauser Collection, ed. Vivian Endicott Barnett et al.

Toledo 1995
Toledo Treasures: Selections from the Toledo Museum of Art.

Figure Credits